DATE DUE

			PRINTED IN U.S.A.

by John McPhee

The Ransom of Russian Art
Assembling California
Looking for a Ship
The Control of Nature
Rising from the Plains
Table of Contents
La Place de la Concorde Suisse
In Suspect Terrain
Basin and Range
Giving Good Weight
Coming into the Country
The Survival of the Bark Canoe
Pieces of the Frame
The Curve of Binding Energy
The Deltoid Pumpkin Seed
Encounters with the Archdruid
The Crofter and the Laird
Levels of the Game
A Roomful of Hovings
The Pine Barrens
Oranges
The Headmaster
A Sense of Where You Are

THE

RANSOM

OF

RUSSIAN

ART

Где пальто с воротником?

Где синий диван?

Где скатерть Зины?

Где платяной шкаф?

Где рога оленя?

Их нет...

THE RANSOM OF RUSSIAN ART

JOHN McPHEE

Farrar Straus Giroux

NEW YORK

rica

er & Ross

N6988 .M33 1994
McPhee, John, 1931-
The ransom of Russian art

k first

ution Data
McPhee, John (John A.)
The ransom of Russian art / John McPhee. — 1st ed.
p. cm.
1. Dissident art—Soviet Union. 2. Dodge, Norton T.—Art
patronage. I.Title.
N6988.M33 1994 709'.47—dc20 94-14723 CIP

*The works of art reproduced in this book were
chosen by Norton Dodge. The photography was
principally done at Cremona Farm by Charles Fick.
All works are from the Norton and Nancy Dodge
Collection of Nonconformist Art from the Soviet
Union, which is now at the Jane Voorhees Zimmerli
Art Museum, Rutgers University.*

FRONTISPIECE
Ilya Kabakov, No. 6 in the series Where Are They?, *1979.
Mixed media on paper. 15⅞ × 10⅝ in.*

To Roger Straus

THE

RANSOM

OF

RUSSIAN

ART

Norton Townshend Dodge, born in Oklahoma City in 1927, first presented his curriculum vitae to officials of the Union of Soviet Socialist Republics in the early spring of 1955. They let him in for thirty days. His stated purpose was to travel with his father (a retired college president) and assist him in a study of Soviet education. Norton did not reveal his real mission. In a journey that encompassed three hundred thousand square miles, he gathered material for what eventually became a nine-hundred-page monograph on Soviet tractors. It served as his doctoral dissertation in economics at Harvard, where he already held an M.A. from the Russian Regional Studies Program, regarded by the K.G.B. as the academic wellhead of American spies.

In this country, Norton Dodge was (and still is) looked upon by his doting friends as a person who has difficulty getting from A to C without stumbling over D

[*3*]

and forgetting B. On his own, he returned to the Soviet Union in the nineteen-sixties. He had become a professor of economics at the University of Maryland. His initial and primary travelling purpose was to learn all he could about (as his book was eventually called) "Women in the Soviet Economy—Their Role in Economic, Scientific, and Technical Development" (Johns Hopkins, 1966). Some of his colleagues said that he was studying "the position of Russian women under Stalin." But Stalin, of course, was gone, and Dodge was obviously far ahead of those colleagues, not to mention almost everybody else, in his absorption in the topic of opportunity for women. He suspected that this was one sociopolitical area in which the American situation might benefit from Soviet example. In those Khrushchev and Brezhnev years, he went from republic to republic, calling on state farms, collective farms, universities, and research institutes, and asking to see hierarchical charts. He could not always count on Intourist to broker these interviews. Tentative at first, he soon became aggressive. He says he would just take a cab to this or that institute and ask to see its leading woman scientist. A K.G.B. person met him at the door and put him in touch with the leading woman.

He had, as well, a hidden and unrelated interest. At Harvard, at the Russian Research Center, he had known a graduate student who had studied economics at Moscow University and had shared living quarters there with a Russian artist. The grad student told Dodge

that the Russian, Valery Kuznetsov, had once been enrolled at one of the Moscow art institutes, learning the techniques of Socialist Realism on his way to becoming an official artist. The style was so repellent, though, that Kuznetsov went underground and painted what he was moved to paint, as an "unofficial artist," a "nonconformist artist," and therefore a "dissident artist"—all terms that were applied to the clandestine painters and sculptors of the Soviet Union in the era from Stalin to glasnost. They consisted of small, close circles, in Moscow and elsewhere, and those that did not have a covering occupation—like, say, student of economics—could be harassed not only as dissidents but as unemployed parasites and be sent to labor camps or mental hospitals, where some of them continued their artistic work. In time, their secrecy diminished and their circles overlapped, but 1962—when Norton Dodge went to the Soviet Union with Kuznetsov's name, address, and telephone number in his pocket—was early in this parabola. Slipping away from Intourist, he called from a public telephone and was soon visiting not only Kuznetsov but also the apartments of Kuznetsov's unofficial-artist friends. They took him to an apartment-exhibition of the work of Lev Kropivnitsky. The informality and the secretiveness notwithstanding, this was apparently the first abstract-art show in Moscow since the nineteen-twenties. In time, the unofficial artists became heroic figures through the drumlike telegraphy of Soviet culture. Kropivnitsky was the brother-in-law of Oskar

[5]

Rabin, who was especially revered. Middle-aged and essentially hairless, Rabin developed the incongruous status of a bald rock star. Dodge bought works of these artists and either carried them in his suitcase or, with larger items, found ways of having them smuggled out. Meanwhile, the Moscow painters gave him the names of underground artists in other cities.

While Norton Dodge is behind a steering wheel on Interstate 95 between New York City and his home in Maryland, he has been observed reading the newspaper. Funnies first. Looking up at his surroundings, he tends to concentrate on the rearview mirror, explaining, "I'm keeping the car aligned." Sometimes the vehicle has been a white pickup with a boxed-in plywood back, full of paintings. Before he retired from college teaching, he sometimes went south on the interstate, writing his lectures with one hand and driving with the other. When he travels by air, archway metal detectors routinely rebuff him. He empties pockets, more pockets; but, back in the A.M.D., he fails. He continues to search himself from knee to chin, not missing the linings loose from the inner tweed. On the tray, he builds a pyramid of metal, with incidental plastic, wood, paper, rubber, and glass. For a third time, he submits himself to the electromagnetic inductors, the result being a bzzzzzzzzzzt, a clang, and a flashing red light. In such a moment, his wife, Nancy, has said to him, "How could you ever get around the Soviet Union if you can't beat your way out of the St. Louis airport?"

[6]

In Ukraine, Georgia, Byelorussia, Soviet Central Asia, Dodge went around in the daytime collecting material for what he calls his "women book," meanwhile figuring out how to contact artists at night. There were no city maps. But he had his Baedeker with him, naturally—the 1914 edition. Although most street names had been changed, the Baedeker was useful. In Dodge's words, "The layout of transportation was not far different." He carried a flashlight—incredible as this seems to people who knew the country in those years—and he used it to find numbers in dim corridors and lightless streets. "When travelling under the aegis of Intourist, it was worthwhile to take one of the general trips around the city and spot the numbers of various streetcars and other things," he recalls. "Not only was I pursuing art but also my other research, so I liked to know where universities or research institutes or the Academy of Sciences were, so that I could go and visit them directly if I felt that I wasn't threatening directly the people I would suddenly descend on." He was, to say the least, somewhat threatening to the artists, but they were willing to accept the risk. "We were all scared to death, all of us, including him," one of the artists has said. "Maybe he needed excitement in his life. It was a threat, a constant physical threat. He could have been killed. He introduced himself as an American professor interested in Russian art. Nobody could make anything of him. He was a mysterious figure—a professor obviously with money. We couldn't understand. He was strange,

[7]

clumsy. He kept dropping things. He was afraid to reveal a name. We didn't know if he worked for the K.G.B., or if somebody who brought him did. He kept his connections quite secretive. He didn't mention his contacts. We didn't ask him. His appearance may have saved him. He didn't look like an American. He was sloppy. He was more like a Russian. If he was Russian, he would have been normal."

Dodge had a great deal more hair on his upper lip than elsewhere on his head. With his grand odobene mustache, he had everything but the tusks. He dressed professor, in tie, jacket—used clothing. Various friends have likened him to an unmade bed. He is absent-minded to a level that no competing professor may yet have reached. He has called a locksmith to come and get him out of a situation that could have been alleviated by a key he later found in his pocket. But he got around Leningrad. He got around Kharkov. He got around Kiev, Odessa, Tbilisi, Baku, Yerevan. By the late nineteen-seventies, he had become too anxious to con-tinue these travels. By then, he possessed a thousand works of Soviet unofficial art. Through his network of contacts, in following years, he multiplied that number by nine. All within the chronological window 1956 to 1986, his collection of nonconformist art from the Soviet Union became by far the largest and (in the scholarly sense) most exhaustive in the world. This way and that, he brought it to his farm, in southern Maryland.

Dmitry Plavinsky, *Old Russian Testament*, 1965. Mixed media. 36 × 23⅜ × 2 in.

Mikhail Roginsky, *Red Wall*, 1965. Oil, electrical wire, and socket on canvas on board. 47¼ × 67 in.

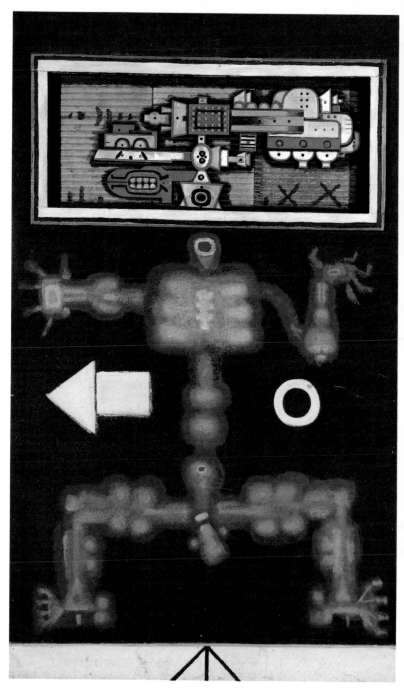

Vladimir Yankilevsky, *The Prophet*, mid-1970s. Mixed media. 66½ × 40 × 3½ in.

Cremona Farm, broadly peninsular, lies between two creeks, fronts the Patuxent River, and consists of nine hundred and sixty acres. There are long-range views over fields to treelines and water. In early morning on the flat pastures, a ground fog will all but conceal the dark shapes of horses. Beyond them are stands of maple, hickory, beech, sycamore, pine, sweetgum, poplar, oak. Half the farm is wooded. Certain of the owner's friends refer to the place as "his plantation." People ride to hounds there. The owner has known horses since his youth, but does not ride to hounds. The main house is Georgian, brick, with six chimneys, and with columned porticoes on both the land and the river sides. There is a pool, emerald with algae, and rosebushes, rampant, going wild beside it. Thorns gradually enveloped a piece of sculpture cast in zinc—bold, not easily movable, a little more than semi-abstract—titled *The Prophet* by the

nonconformist sculptor Ernst Neizvestny, who once survived what Dodge describes as a "toe-to-toe, face-to-face, knockdown discussion" with Nikita Khrushchev about the themes of unofficial art. Later, Khrushchev's family chose Neizvestny to design Khruschchev's gravestone. The sculpture beside the Cremona pool was spirited out of the Soviet Union with the help of a German diplomat.

It's a short walk to the edge of the Patuxent, which is more than a mile wide and much like the Chesapeake it feeds—drowned rivers, both of them, widely and enduringly flooded when ice melted in the north. Cremona's dock is six hundred feet long, extending straight out in the shallow water to reach the one-fathom curve. The far shore is as wooded and rural as the near one. This panorama is not seriously blemished by the coal-fired power plant a few miles upstream.

The farm's driveway is a terrestrial version of the farm's dock. One straight stretch of it runs more than a mile. West of the flat pastures, it meanders through hilly woods and comes to brick pillars at Maryland 6. Dodge once employed a tenant's young son to fetch the newspaper at Maryland 6. Each morning, the boy's round trip was more than two and a half miles. Dodge paid him seven cents a week. About halfway up the drive, at an intersection of farm roads, are eleven mailboxes in a row, one larger than the others. There are about forty buildings on Cremona, well spread, eleven of which are human habitations. There are hip-roofed barns, louvered tobacco barns, tall saltbox gabled

barns—silver weathered-cypress barns, covered in part with carriage vine. The music barn. The brick horse barn. Under its tall cupolas and outsize weathervanes, the brick horse barn resembles a stable that President Washington built at Mount Vernon. To Russian artists visiting Cremona Farm, the milieu it has brought to mind is from a deeper stratum: "His tenants seem to be serfs. He lives in a pre-capitalist era. He's still in the feudal system. Artists who served feudalists were better off than artists are now."

In a general way, Dodge refers to himself as an "on-the-site absentee landowner." Wine is made at Cremona, from Mediterranean hybrid grapes: Vidal, Villard Blanc, Seyval, Chambourcin, Villard Noir. The winemaker is a retired professor from the University of Maryland, whose name, as it happens, is not Norton Dodge. While Walter Deshler comes each year as visiting vigneron, Norton Dodge has yet to crush his first grape, but of course he is the labelled *propriétaire*. Billy Morgan farms Cremona, paying rent like the tenants, and growing more than a hundred thousand dollars' worth of soybeans, barley, wheat, and tobacco, and sharing proceeds with the landlord. Of Deshler's efforts, Morgan says, "Some of that wine is good wine and some will take your head off."

Norton Dodge spent more than three million of his own dollars on the art of the Soviet underground, but in all other ways he is the antonym of spendthrift. Surveying the broad Patuxent, the long boatless dock,

he will say, "The best way to do your yachting is to look at other people's yachts." To attain an antebellum polish, Cremona would require a large staff of gardeners, housemaids, and handymen, who are not there. Professor Dodge is there, alone much of the time, struggling indoors to keep up with his paperwork, while the carriage vine grows, the cypress weathers, and Cremona itself ferments. Sarah Burke, a professor of Slavic languages and literature at Trinity University in San Antonio, has said, "Cremona could be one of the estates in 'Dead Souls.'"

Ante-Norton, Cremona was owned by an army officer whose very rich mother-in-law had offered to buy her daughter and son-in-law a house if it was within fifty miles of Washington. The officer went up in a small plane, flew around, spotted what he wanted, and marked it on a map. He drove there. It was Mount Vernon. He took off again, and found Cremona. President Franklin Roosevelt came to visit, in the yacht Sequoia. When Dodge, between travels, bought Cremona in 1966 and began to stuff its barns with Russian paintings, he was an untenured professor still in his thirties.

I met him on an Amtrak train in Union Station, Washington, in January, 1993. Casual as that. He came into an empty car and sat down beside me, explaining that the car would before long fill up. It did. He didn't know me from Chichikov, nor I him. His button-down buttons weren't buttoned. He wore khaki trousers, a

green tie, a salmon shirt, a tweed jacket with leather elbows, and a rubber band as a bracelet. An ample fringe of hair all but covered his collar. His words filtered softly through the Guinness Book mustache. It was really a sight to see, like a barrel on his lip. Two hundred miles of track lie between Union Station and Trenton, where I got off, and over that distance he uttered about forty thousand words. After I left him, I went home and called a friend who teaches Russian literature at Princeton University, and asked her who could help me assess what I had heard, since my qualifications, with respect to the relevant topics, consisted of a used train ticket. She mentioned Marian Burleigh-Motley.

Burleigh-Motley is an art historian in the Education Division of New York's Metropolitan Museum, and her special field within modern art is Russian painting, particularly of the late nineteenth and early twentieth centuries. She told me that Dodge's collection was unique, and that in amassing it over the years he could not have had any sense that it was a good investment. "He could not have anticipated that it was worth money. He likes the stuff, and that is why he did it. What he collected is therefore more idiosyncratic and more admirable." In a later conversation, she said, "I would stress the joy that he got out of collecting," and she added, "If he hadn't collected these works, many of them might have been destroyed. This was a great moment in Russian art—the sixties and seventies. They

[the younger artists] never talk about it now. It's the sons and the fathers." In passing, she referred to Dodge as "a cuddly teddy bear of a man."

The art critic Victor Tupitsyn, who is Russian, said to me, "It wouldn't be an exaggeration to say that Norton singlehandedly saved contemporary Russian art from total oblivion. This makes him an evangelical figure."

On March 23, I went to Cremona for the first time. It was a raw day on the edge of the Patuxent. The farm appeared to be the sort of place where you would expect to find something other than pie filling inside the pumpkins. A door would slide open. The figure that emerged was Russian. There were Russians in the library, Russians in the barns—transient, here-today, gone-tomorrow, nonresident Russians. And there was Dodge, said to *look* Russian, in his luffing corduroys, his perennial tweed, his wine-dust sweater, his once-white shirt and abused red tie. On his head was a blue fits-all baseball cap lettered CREMONA FARM.

Drawings were in the library, a small freestanding building; the paintings were in a tobacco barn and the brick horse barn. At least from the standpoint of preservation, you would not have compared these barns with the Beinecke rare-books library at Yale. A cat had once gone round-the-bend and damaged some of the paintings. Others had been stained by raccoon urine and raccoon feces. But such accidents had affected a minuscule percentage of the whole nine thousand works of art. "The Russians thought the paintings were

better off here than in their homes in Russia," Dodge remarked. Stretched canvases of various dimensions were stacked vertically in horse stalls, or in bins in ceilinged rooms made of plywood. There were air conditioners, dehumidifiers, heaters. The collection represented more than six hundred unofficial artists.

The interior of the tobacco barn was an artwork in itself, with its lofted complexity of hewn beams and pole beams, its moted space, its illusion of volume. Some of the art was too large for the plywood rooms. In the tobacco barn's great central space was a Yakerson six and a half feet high, thirteen feet wide. To the question "Who on earth could have smuggled that out of anywhere?" the answer was "Josef Yakerson": he had rolled it in a carpet, and had rolled a dozen other large canvases in other carpets, and had taken them all with him when he went to Beersheba in 1973. The theme of the painting was classical but scarcely official. A mostly human figure with a demented countenance and a huge double set of hairy bull testicles was shoving a swan aside and addressing his parts to Leda-Europa from behind. He had a firm grip on her abundant hair. Dodge critiqued the piece, saying, "One can see why that was not favored."

This was by no means the only outsize painting he had, but the majority were of modest dimensions, and many were quite small. A good many were abstract. Dodge pulled canvases randomly from bins: Nazarenkos, Bulgakovas, Shteinbergs; work of Kopystianskaya, of Kabakov the superstar, of the photorealist Faibiso-

vich, the Sotsartist Sundukov, the iconic architectonic Shvartsman, the organic Yankilevsky (heads emerging from anuses). Abstractions aside, themes ranged from pornography through religion to politics (a red star with a nail through it). A Pivovarov consisted of twenty-one words: "Go and wash your face. People are coming soon. It is not good for them to see you looking like this." He came upon a Rukhin; and he came upon a painting by Galina Popova, who was married to Rukhin. They lived in Leningrad. He died in a fire in his studio in 1976. In 1978, she had done this portrait of him, in which his great ursine head with its ruff of dark hair stood forth against a broad red cross. Dodge said, "They had three children. He supported them on his work. That is probably why they killed him—as an example." In a stall in the brick horse barn was Yakhnin's post-modern Schick razor blade, done in 1986, at the far side of Dodge's temporal window. "They would be very aware by the nineteen-eighties of what had gone on in the U.S.," he said. "In the fifties and sixties, some would be getting art journals from cultural attachés, but most would not. Mikhail Roginsky did pop art, and early examples of the satirical Sotsart, in the fifties. So he was up with the West. While Warhol was doing soup cans, he was doing toilets, chunks of wall—nauseous-looking walls with electrical fixtures proliferating: what you would see, if you were Russian, when you woke up. Doesn't seem like much to us, but there he was, shutting off his career, transcending all kinds of rules. He could

be picked up any time and sent off to a labor camp."

In the bins were numerous paintings with coarse or subtle connotations in contempt of the Soviet regime, only a few of which, I thought, had risen past the level of political cartoons. It was not to be my purpose, however, even to approach an evaluation of the art in this collection. My interest would lie almost wholly in the collecting. What Dodge had evidently assembled was not so much *of* an era as the era itself. It was the whole tree—the growing cambium with the dead wood. If his motive was higher than money, it was also higher than the aesthetic level of any given work. He had released into the general light a creativity whose products had been all the more concealed because they were untranslatable and awkward to move. With it, he had released the creators.

The farmer Billy Morgan had once or twice seen the pictures. One morning, he told me, "I never really did take interest into 'em. They tell me most of 'em came from Russia. I swear to God I don't know where they came from. Some of 'em caught your eye, some of it didn't. If you had six girls standing in front of you, one of 'em would catch your eye quicker than the other five."

Dodge was still adding to his collection, filling gaps in its definitive spread. A panel truck covered with graffiti arrived on one of those gloomy March days and parked beside a tobacco barn. The driver was a young Russian and the truck was full of paintings by an artist

from Irkutsk. They were in stacks, like mats or rugs, for the most part unframed. One after another, the driver drew them out for Dodge to view. Dodge bought one that was the size of a bedspread, and a large stretched one, and four small ones. It was as if he were buying fish.

In the barns, in the stalls and bins, some of the works that Dodge pulled out had been painted on stretched tablecloths. Some were framed in wooden rulers. The underground artists would paint on anything. There were works done on burlap sacks. One was on a Cuban sugar sack. The artist had incorporated its logo into the art. There were works on scraps of metal, on wood, on cardboard. A painting that Dodge described as "a phantasmagoria, a potpourri of human-oid monsters," had been done on oilcloth in 1973. The "oil" side, checked, was now the back of the painting. It appeared to have spent innumerable years spread on a kitchen table.

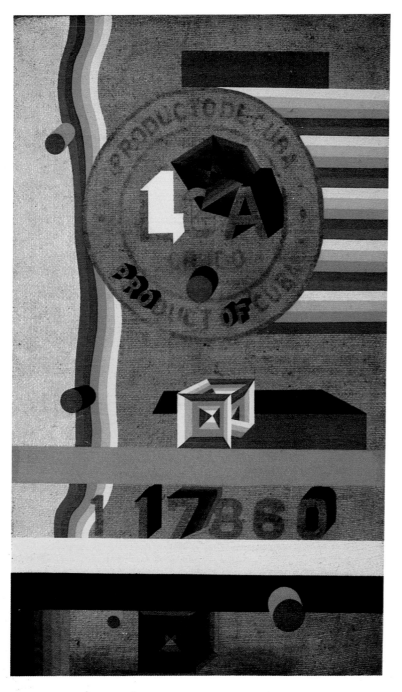

Vladas Zilius, untitled, 1971. Oil on sugar sack. 41½ × 24⅜ in.

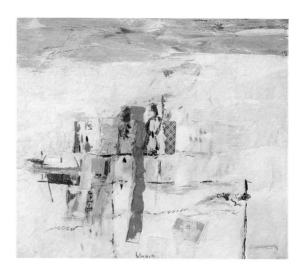

Vladimir Nemukhin, *Poker on the Beach*, 1974. Oil and playing cards on canvas. 26¾ × 31 in.

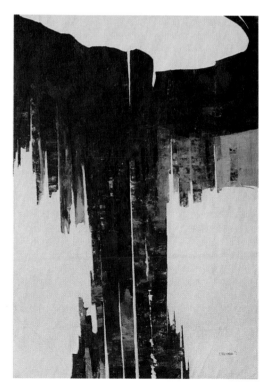

Lydia Masterkova, untitled, 1971. Oil on canvas. 59¾ × 42½ in.

Official artists had access to paints, canvases, and other art materials in official stores. Unofficial artists did not. In Dodge's words, "They had to wangle things one way or another. Or they had to use oilcloth or wallboard or something. The paint might be automobile paint. To get gouache or acrylics, they had to have foreign connections, or friends who were official artists. Members of the Artists Union could get stretchers and frames, but nonconformists had to improvise with rulers, yardsticks, plain strips of wood. A typical nonconformist frame used no more than a handful of tacks. They didn't have staple guns. I often took a staple gun with me, and a bunch of staples. Sometimes they painted on wood, or on the back sides of posters or the back sides of scrap paper. Tonis Vint did prints on what we would consider to be poor-quality wrapping paper. They painted canvases on both sides if the first side was not

liked. They painted over earlier paintings." (When Dodge was about ten years old and his father was dean of the graduate school at the University of Oklahoma, his father helped set up a campus art studio for native tribes. "The idea was to give the Indians something better than wrapping paper or sacks to work on. My interest in art developed there. I began collecting Indian art in my college years.") In the sixties in the Soviet Union, there was a story that spread from artist to artist, circle to circle, city to city, about a small golden fish. It was based on a Russian fairy tale. An artist catches the golden fish. The fish says to the artist: You are to be granted three wishes. What do you wish?

Artist: A dacha by the sea.

Fish: Granted. What more do you wish?

Artist: A woman to go with the dacha.

Fish: Granted. What more do you wish?

Artist: To be a member of the Artists Union.

Fish: Granted. You no longer have any talent.

Dodge himself may have helped to circulate the story, moving from one to another of the small circles that were geographically scattered or had not yet co-alesced. Only their friends knew of the artworks jamming the artists' apartments—tessellated up the walls, nailed to ceilings, thickly piled under beds. In a new building intended to relieve crowding, he called on an artist who was living in one bedroom with his mother while another family lived in the main room of the apartment and shared the kitchen and bathroom. If an unoffi-

cial artist had a separate "studio," it was typically under big low pipes in a basement. To see the work of Ilya Kabakov, Dodge climbed six flights of stairs to the attic of an apartment building, went through an extremely narrow door, and somehow kept his balance on planks set on rafters, avoiding a fall through the ceiling of the apartment below. Finally, a door opened into a wide workplace. Some of Kabakov's paintings on pressboard were so large that there was no way to remove them.

Male artists were, in the main, supported by their wives. Since the Decree Against Parasitism was both formal and enforced, some male artists bestirred themselves to stoke coal or run elevators. But the women, generally speaking, had a heavy burden, a double burden. Not a few of them were artists, too. In Moscow, Lydia Masterkova was married to Vladimir Nemukhin. Valery Gerlovin was married to Rima Gerlovina. Olga Potapova was married to Evgeny Kropivnitsky, and their daughter Valentina Kropivnitskaya was married to Oskar Rabin. In Riga, Dzemma Skulme was married to Ojars Abols. In Tallinn, Sirjee Runge was married to Leonhard Lapin. In Tbilisi, Nino Morbedadze was the wife of Dato Shushanja. And so forth, wherever Dodge's travels took him. The women often had at least as much talent as their husbands did, and the women prepared the sandwiches while the men drank vodka and held forth on art theory.

On Dodge's first journey, in 1955, the Intourist escorts had been so closely attentive that visiting people

in their homes was out of the question. Even had it not been, Dodge and his father would have had a difficult search if they had wished to find unofficial artists. "They were just starting to emerge. This was before Khrushchev denounced Stalin. Stalin was still too close. The circumstances of the police state were still very strong. There's not much likelihood that very much was going on in the way of underground art." A few unofficial painters were doing landscapes, still lifes, and portraiture, but little more. At that time, there was essentially no abstract art. After painting furtively and showing only to close friends, artists were destroying their own work. In the twenty previous years—before, during, and after the Great Patriotic War—materials were unobtainable and there was no unofficial art. The artist Alexander Melamid, who grew up in Moscow, asserts that in any case nothing much would have been produced, because in Stalin's Soviet Union no artist would have thought to defy the system: "The society was united then, in a strange, ideal way." Melamid was eight when Stalin died and ten when Dodge first went to Moscow. Interested in learning how much Western art there might be in Soviet galleries in 1955, Dodge found very little in Moscow's Tretyakov, but in Leningrad at the Hermitage "Picassos, Matisses, Cézannes, and Gauguins had just been brought up from the storage cellars for the public to see." Later in the fifties, after Khrushchev denounced Stalin, things thawed to the extent

that Rockwell Kent was put on display in museums of modern art. Unofficial artists began to paint unofficially. The period in art history that is now represented by Norton Dodge's collection had opened.

In 1960–62, the junior economics officer in the American embassy in Moscow was a school friend of Norton Dodge named Julian F. ("Pete") MacDonald. Dodge and MacDonald were graduates of Deep Springs, a small California ranch school in an isolated valley so far east of the Sierra that it seemed to be in Nevada. In 1950, they had worked together as waiters in the Russian dining hall in the summer language school at Middlebury. Both earned degrees in the Russian Regional Studies Program at Harvard. While Dodge was going around Moscow talking to and about women, he gravitated to the embassy, where he could eat hamburgers and talk to MacDonald. He mentioned his interest in artists. MacDonald mentioned George Costakis, who had been born in Moscow in 1912, was married to a Russian, presented himself as a Greek citizen, and worked as an administrative clerk in the Canadian embassy. MacDonald's wife, Allen, was tutoring two of Costakis's children in English and had found Costakis's apartment of more than routine interest because—a large one by Soviet standards—it was crammed fuller than a warehouse with Russian art. A chunky, bespectacled, Attic man, Costakis was the liaison between the Canadian embassy and the Soviet govern-

ment. From the viewpoint of the foreign diplomatic community, it went without saying that he reported to the K.G.B.

"When I first got his address and first visited him, I was hardly prepared for the elaborate strap-iron-covered doors and multiple locks, like an impregnable-fortress entrance, that he had his art behind," Dodge recalls. There were three rooms, furnished with the modern sofa and Danish tables that seemed to Allen MacDonald to be "like an American existence." Costakis's collection, like so many others, started under the beds and went up the walls and over the ceilings. Unlike others, though, it was worth untold millions of dollars, because it consisted almost wholly of antique icons and of paintings from the early twentieth century by the Russian avant-garde. Kandinskys. Chagalls. Rodchenkos. In words of Costakis's biographer, the former Canadian diplomat Peter Roberts, "Their paintings and sculptures and designs were lost or hidden. To exhibit or collect their works, or even to possess them, was highly dangerous. Costakis collected them anyway. He saved thousands of works from almost certain loss, and did much of this at a time when Stalin's persecution of art and artists was at its peak of frenzy. He was finally hounded out of the country by the K.G.B., as at about the same time were Solzhenitsyn, Rostropovich, Brodsky, Sinyavsky." In the hunt for his trophies from the avant-garde, Costakis had become acquainted with contemporary artists. He gave parties in his apartment for

them. He bought the work of a selected few. Dodge continues, "I could see on his wall the works of non-conformist artists I had yet to meet. Plavinsky. Krasnopevtsev. Nemukhin. Zverev's self-portrait, with his slashing strokes of paint. Out of it emerged his face; he looked like a madman." Dodge's friend the Leningrad poet Konstantin Kuzminsky says of Costakis that "he collected the cream of Moscow underground art, only the cream—he left the milk."

Costakis put Dodge in touch with whey, milk, cream, and butter, and also mentioned Nina Stevens. She was Russian, and she had once dealt in foreign merchandise on the general level of nylon stockings. Inspired by Costakis, she had begun collecting nonconformist art and artists. In the seventies, Dodge would pay her fifty thousand dollars for some of her collection, on the average of a thousand dollars a painting. Meanwhile, he was invited to the art-viewing parties that she gave in her home on Saturday afternoons—events tantamount to a salon. Her husband was the American journalist Ed Stevens, who had been assigned to the Soviet Union in the nineteen-thirties and, essentially, had never left. He worked variously for *Life*, *Time*, *Look*, *Newsday*, *The Saturday Evening Post*, NBC radio, *The Times* of London, *The Manchester Guardian*, and *The Christian Science Monitor*. Across the river from the Kremlin, they lived in what she fondly remembers as "a fantastic *izba*," a log cabin—large, rambling, picturesque—where they served caviar in great dollops out of ten-kilo tins. Later,

they moved into a stone mansion with tall stately windows, which Nina caused to resemble an art museum. For many years, it seemed to foreigners in Moscow that this was the only place you could go where you could meet Russians, the fact notwithstanding that the K.G.B. clearly knew that she was supporting unofficial artists. Dodge remembers Ed Stevens and his companions drinking full tumblers of vodka in a few gulps. "He would then pull out a sharp knife and start slicing tomatoes, never catching his finger." The presence of an artist or two was a part of the salon's attraction. In 1965, Dodge met Vasily Sitnikov there. Bearded, byelobohemian, he was dressed in peasant boots and peasant blouse. Dodge remarks, "She was showing him—using him as dancing bear."

Sitnikov's apartment, where several families lived, was very close to Dzerzhinsky Square and the K.G.B. headquarters at Lubyanka Prison. The eccentric artist had had numerous difficulties with the authorities. In order to be sure that an approaching caller was his own specific invitee, he dangled from a window a small artistic decoration at the end of a string. Dodge pulled the string. This caused a bell to ring. Sitnikov came down and let him in. "The place had one bathroom, one kitchen, food on the windowsills to keep it cool, uneven floors—it was a rattletrap. He was crammed in with all his artworks. He was dressed in a less peasanty costume than at Nina's, but he had a rough country-boy look about him, the product of a life in the

outdoors." A light kayak hung from the ceiling—"in itself a work of art." Sitnikov was an early key figure among unofficial artists. Others had their beginnings with him. With regard to Sitnikov himself, Dodge was equally drawn to art and artist. He admired Sitnikov's religious themes, his "impressionistic, almost ethereal nudes," his "snowy wintry scenes of kremlins and churchyards and churches, in the foreground cats and dogs fighting or a militiaman dragging a drunk to a police car." As if these things were not enough to pull a bell at Lubyanka, there were Sitnikov's "scatological paintings, which, if he had ever tried to show them, would have gotten him into even bigger trouble." Sitnikov had at one time been imprisoned in a mental institution so that he might "shape up ideologically." He had done a pencil drawing of an inmate there, in straitjacket. The face had no mouth. Because of the circumstances of composition, he said, he could never complete the mouth. In the course of things, Sitnikov would sell his work not only to Norton Dodge but to Augusto Pinochet, Gina Lollobrigida, Elizabeth Taylor, Carlo Ponti, and Sophia Loren. Sitnikov is dead. Nothing of his is in Russia now. The drawing with no mouth made its way to Maryland.

In the nineteen-sixties, the artists were not competitive in the way that, with glasnost, they were destined to become. In those early years, they freely gave Dodge any information they might have about work being done in Moscow and other cities. An artist's name would

be mentioned and someone would say, for example, "He's a fine young man in Leningrad. Here is his phone number. Don't call him from your hotel." With his flashlight, his safety pins, his Scotch tape, and his other high-tech devices, Dodge carried in his pockets as many two-kopeck pieces as he could gather, because they alone would work in a public telephone.

"Norton just pushed every envelope," Pete Mac-Donald recollects. "He had a visa with limited access, but he would push the envelope further, push it as far as it would go. The Soviet government kept things away from the outsider. As the embassy's economics officer, I got to go to a cement plant, a fish cannery, a ladies' underwear establishment, and a collective farm. It was like pulling teeth to get under the surface. But Norton would just go into some bureau and say, 'I want to learn about cotton production in Kazakhstan.' And he went to Kazakhstan. Not being in the government, Norton was coming from a different direction. He was like a naturalist in a country for the first time."

Dodge was sometimes the first American the artists had encountered, and certainly the first they sold things to. Professor Sarah Burke remembers from her own experience in the Soviet Union in those years that "Americans were almost worshipped," and she goes on to say that "Norton—with money, buying paintings— would have been one of the most desirable people anyone wanted to see." According to Elena Kornetchuk, whose gallery in Sewickley, Pennsylvania, is probably

the only one in the world that specializes in Soviet unofficial art, "Norton, to the artists, was a man out of nowhere, a prince on a white horse. They felt some amusement when he liked bad things. He wanted the art to be dissident—to be outrageous: utterly unacceptable [to the regime]." In Lithuania, for example, he was engrossed by the work of Vladas Zilius, not only because some of it was so abstract that it was officially considered pornography, but also because Zilius had painted people with fresh bullet holes through them despite their raised hands.

Dodge would outline his own itinerary and arrange it with Intourist, with the stated purpose of interviewing women. Soviet economists put him in touch with them in the way that artists led him to other artists. He was trying to see what he could learn about the fortunes of women during the first, second, and third five-year plans, and in the postwar period. "Technically and legally, and in terms of access to careers, it was much more open for them in the Soviet Union. A lot of doors were open to women. But it didn't reduce their load of family responsibilities. The men often would never lift a finger. The reality was that although women in Russia had career opportunities opened up to them they still had to carry the burden of all the cooking, all the washing, all the cleaning, and all the child care except insofar as there might be public child care. Our child-care facilities were abysmal. In the Soviet Union, child care was also rather abysmal; but at least on paper they

had high purpose, and they actually provided at the factories child care that was connected with the place that the women worked, and they had other child-care facilities for the day and also for whole periods of time when people were in seasonal work, like herders and so on that would go off into the mountains; and in summer on the farms they would have in-the-field child-care facilities. Another thing was abortion. Lacking other means of contraception, a lot of Russian women were overly dependent on abortion. Care may not have been very good, anesthetics often were not provided. But it was legal. The principle of legalized abortion was accepted—at a time when women in the United States had to go to quacks or abroad. I felt that in many ways women were discriminated against in the United States in a rather shameful fashion. Many areas that were closed to American women by tradition or convention had been opened up in the Soviet Union, legally, so that the proportion of women was positively increased. Forty percent of engineers were women. In mathematics, the percentage of women was well above ours. The percentage in the legal profession was substantially higher. At the peak of a profession, though, you could see the winnowing out of women. You might have a lot of women doctors—seventy-five percent—but by the time you got to the membership in the Academy of Medicine there might be two or three percent." Dodge obtained counts of the percentages of women at various levels in universities, and in different fields at universi-

ties. He determined the percentage of research articles written by women. None of this had been published. He just went around and found out.

In his hidden mission, he was not infrequently frustrated. In Baku and in Kiev, for example, he attempted to make contact with artists but failed. He knew their names but could not get to them. In tufa-built, desert Yerevan—the snowcap of Ararat floating on the southern horizon—artists outnumbered goats. In stone and stuccoed crumbling Tbilisi—its funicular rising to the statue of the mythical mother of Georgia —he saw the widow of Kakabadze. Her husband had exhibited in Paris in his youth with Picasso and Matisse. When he came back to Russia, after the revolution, he had to alter his style to fit the strictures of Socialist Realism. His impressionistic landscapes of the Caucasus changed little in their backgrounds, but in their fore-grounds they developed steel smelters, factories, and cement plants. Kakabadze's son was now working in three-dimensional assemblage—bits of metal, clothing, real hair, a fish spine on a plate—and was in the mainstream of nonconformist Georgian art. In the dim courtyards of Tbilisi buildings dating from the fifteenth and sixteenth centuries, Dodge felt "peculiar," as he puts it, blinking his flashlight, and "trying not to stumble in on too many people," because his Russian was not the best, his Georgian was nonexistent, and in any case it would be difficult to explain what he was doing. One night, shuffling forward in the dark from one door to

[*35*]

the next along a courtyard's second-floor balcony, he was looking for Alexander Bazhbeuk-Melikian's young widow. Peering through a window, he saw a woman sleeping, half-disrobed. "I thought: This is the address. Here I am. Will I ever be back? What should I do?" He cleared his throat. He stepped heavily. He coughed. He tapped on the window. She woke up and showed him her late husband's paintings.

When he bought small paintings or drawings and other paper things, he packed them flat or rolled them up and took them with him. Larger works, he says—his thick eyebrows merging with his mustache—"had to go through channels." In or out of his suitcase, the accumulation of art gave him a logistical problem, compounding all the other problems of being on his own in the dark and cableless streets of strange cities, "finding your way around, finding apartments in the outskirts, stumbling through all this, and after midnight asking yourself, How do you get back? When you add it all up, you wonder how you did all that."

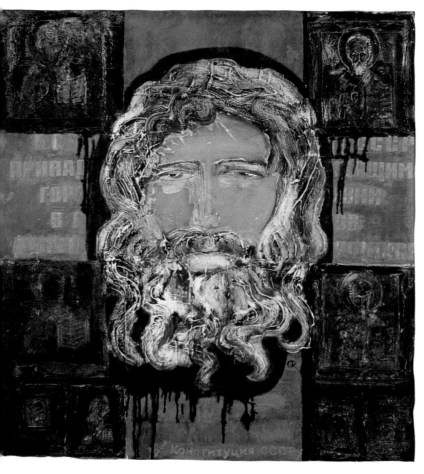

Galina Popova, *Portrait of Rukhin*, 1978. Mixed media on canvas. 39¼ × 37¾ in.

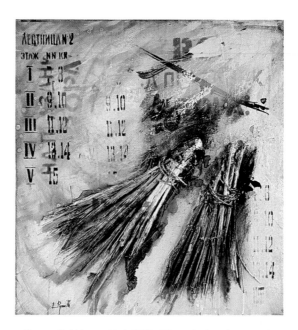

Evgeny Rukhin, untitled, 1975. Oil, synthetic polymer, and assemblage on canvas. 26 × 27½ in.

Evgeny Rukhin, untitled, 1975. Mixed media on canvas. 39½ × 39½ in.

In the nineteen-seventies, in Leningrad, Dodge met Evgeny Rukhin, a key figure in the dissident movement. He was an unofficial artist of exceptional talent, who also—in his incautious, magnetic, unofficial way—was an organizer of other artists. He spoke English, French, and German; and that, in the words of a colleague, "gave him a form of power." He was nearly two metres tall. Under his head of dark hair—its rolling curls spreading out in great radius—his beard, brown and red, broadly fell halfway down his chest. When he walked on a street anywhere, people turned around. The K.G.B. turned around. He could not have been hard to follow.

This is how two friends remember him:

"He was almost like Rasputin."

"Yes, but he was more intelligent."

"As we know, a lot of Russian men can very easily turn into monsters with a lot of vodka."

Though his hair was bohemian, his clothes were not black leather. Away from wet paint, he wore dark suits, white shirts, paisley ties. His tortoiseshell glasses seemed academic. His degree was in geology. At Leningrad State University, both his mother and his father were professors of geology. One of his grandfathers, who had been a military topographer in the army of Nicholas II, was sent by the Soviets to a camp in Kazakhstan. According to Rukhin's widow, Galina Popova, Rukhin's father was a lecturer who drew so many students that the K.G.B. had him killed.

Killed? A geologist?

"Brutally killed, by a truck, in 1959, by the K.G.B. At that time, you could not be above the crowd by a head. Or your head would be levelled. My husband was above the crowd by his beautiful height, and his head was levelled, too."

She married him in 1965, when she was a student at the Leningrad School of Industrial and Applied Art. Brown hair, green eyes—she was so small that if he held an arm out level she could walk under it. Her hand, spread wide, exactly covered his palm. Their friend the poet Kuzminsky thought them romantic figures: "No matter what he wore, he looked as if he were in a tuxedo. She, with elegant décolletage to her belly button. They were the couple to represent Leningrad."

[*40*]

After their daughter Masha was born, in 1966, Evgeny said to Galina, "Would you mind if I stayed with the baby and did not go to work?" She agreed. She worked hard at her official art—her stained glass, her mosaics—and achieved membership in the Artists Union. She had paper, canvases, and so forth, and supplied him with them. By her description, "he held the baby on his left arm and painted with his right hand."

Rukhin was somewhat contemptuous of her official status. "He needed this protection," she continues. "Without it, he would have been sent away." Trained in rocks, he was an autodidactic artist. With dashes of realistic imagery, his work was essentially abstract. She drew for him, if necessary. A Madonna, for example. "Then he says, 'That's enough. Get out.' Then he put the beautiful colors and touches to it. There cannot be two equals. I gave him the priority because he needed a constant reminder of how great an artist he was. It was like food for his self-esteem."

Galina remembers 1971 as their best year. Their son, Lev, was born. She had found a beautiful apartment on the Embankment, two stories, dating from 1738, with walls two feet thick and ceilings so high and vaulted that the place seemed to have a concert hall's acoustics. When the Yale Russian Chorus came to Leningrad with a repertory that included Russian church songs, it was not permitted to sing them, so Rukhin invited the chorus to sing in his apartment. It was August. He left the windows open. They came three nights. Crowds assem-

[*41*]

bled outside. The Yale students, singing lullabies, passed the baby along from hand to hand. On the third night, they gave a violin-piano-flute concert of sixteenth-century court music. Galina describes them in their "bluejean suits," and says, "They got so drunk they had to be carried home."

Around the corner, a block or two away, was Galina's studio, which, by now, he had taken over. It was above the former stables of what had been an English church. Heaped with flammable clutter, narrow stairs led up to it, as if it were the loft of a boathouse. There were three rooms, hewn beams, arched windows, naked bulbs, a skylight installed by Rukhin—a paradise for a Russian painter, official or otherwise.

Galina sought commissions, under which he could be hired to do menial work as her assistant. ("Eugen needed some official status or he'd be arrested as a bum.") At the Leningrad Liquor and Vodka Production Plant, she adorned the foyer with a bas-relief bust of Rukhin pouring liquor. On the wall opposite was her own self-portrait with lute. Rukhin's job was to lug these works to the plant and install them. When he sniffed the prevailing aroma there, he immediately drank what Galina describes as "buckets of vodka," and, like the Yale students, "had to be carted home." Watching Yul Brynner in "The King and I" at the American consul's one night, he drank her drinks and his. At two in the morning, walking home, he lay down on a lawn and put his legs on a granite wall. "I got a feeling that the

ground was taking him, taking him—he was dissolving in the ground." She decorated the quarters of the Pioneers, a young people's organization. Pregnant again, she painted the interior of a police station. Kuzminsky, recalling this, says, "Maybe Russian art will never appear without the wives and girlfriends of the artists. They sacrificed themselves for the artists and for art."

Norton Dodge remembers walking with Rukhin to the apartment of another Leningrad artist. They stopped to buy a bottle of vodka at a kiosk where the surrounding ground for tens of square metres was deeply stratified with bottle caps, all of which had covered alcohol. Later, Dodge handed Rukhin a questionnaire he carried around with him—where were you born? where and what did you study? and so forth—and found to his astonishment that Rukhin couldn't write. Dodge thought: How remarkable—an illiterate artist. But it was just vodka.

Once in a while, Rukhin dived into the Neva for a murky midnight swim. He was in no way cautious. He was not afraid of the authorities. Women were drawn to him and he to them. He slept until two or three in the afternoon, and if the privacy of his studio was not invaded he would paint alone into the night, his layered gesso drying on one canvas while he worked on a second and a third. "I was not usually encouraged to come to the studio without calling first, because I might see something not so pleasant," Galina says. "He was wo-

manizing, of course. He was a free-spirit artist. To confine him in an apartment would be a torture for him and for me. You cannot squeeze a person physically. He was my husband and I respected his privacy. With us, it was all about art. I would give the last drop of my blood to save him."

In the days before Rukhin had access to art materials, he had gone so far as to lock himself in public toilets, remove hand towels from their loops, stretch them, and paint abstracted cityscapes in tempera on the towels. In the studio over the stables, with spray paints and tubs of gesso and canvases from the official supply, his output was prodigious. More bold than confident, he would "produce paintings like an assembly line," according to Victor Tupitsyn, and when he had a large number he would invite his friend the artist Vladimir Nemukhin to come from Moscow and tell him what was good. "Nemukhin picked five. Rukhin threw the rest away." Surviving his short career are roughly a thousand canvases. Merely by being abstract, he was breaking the Party line. He often used found objects against an abstract background, alone or in collage— fragments of furniture, keys, hardware, pieces of tools, a mousetrap. In one piece, an almost unrelievedly white surface was punctuated by a wrought-iron nail. Handmade, large, protruding, and real, the nail had a painted shadow.

Some of his pieces were a good deal more figurative. Galina refers to them as "his nervous, tragic paint-

ings—deformed faces, varitextured hands, a head in a noose—the result of his father's death." He frequently used icons as signets, pressing them into thick soft gesso. In other ways as well he evoked the Russian Orthodox Church. Probably not a believer, he was primarily evoking the Russian past, and this caused others to speak of "the Russian reality" in his work and enhanced its unofficial popularity. Like so many others, he could become explicit to the point of journalism. In a collage mousetrap was a tube of paint—its middle mashed down, contents squeezed out and wasted. "Rukhin caught a great deal of the oppressive dangerous environment that most Russians lived in and artists in particular," Dodge says. "A number of his paintings have stencilled across them—as if they were packing cases—the words 'Dangerous for Life.' "

In words of the artist Alexander Melamid, who knew Rukhin in Moscow, Rukhin was "influenced by early Rauschenberg—the best Rauschenberg." In the sixties, Rukhin wrote to galleries outside the Soviet Union and obtained exhibition catalogues. He invited Jamie Wyeth and James Rosenquist, among others, to visit him in Leningrad. Both of them did. In the pre-glasnost years, what the Soviet underground artists knew of modern Western painting for the most part had to be gleaned. When Soviet periodicals criticized Western art, they showed examples of what they were slamming. "*Krokodil* cartoons of Western art were not far from reality, since the cartoonists were good Socialist Realists,"

Dodge remarks. "There was a Picasso exhibit in Moscow in the fifties, swamped by young artists. After all, Picasso was a Communist, at least in name. The unofficial artists would get to see some Western art by going to an art institute to see journals that might appear there, but by and large the artists would not have known much of anything about what was going on in the West. On the whole, they were not influenced by the West. Although, after giving a copy of *Playboy* to Rukhin, who passed it on to Oskar Rabin, I got a painting by Rabin that obviously reflected his familiarity with centerfold work in *Playboy*. So you do have some clear cases. But non-conformist artists quickly found their own styles and their work can easily be distinguished from all other work, including Western things." *Playboy* was illegal in the Soviet Union. Dodge had smuggled it in.

By other underground artists, Rukhin has been compared to Jackson Pollock and Willem de Kooning, but only in the sense that Pollock and de Kooning were "drunks, chauvinists, womanizers, workaholics." After Rukhin finished a bottle, he put his calling card in it and tossed it into the Neva. He said he wished to be known outside Russia. He became known on at least three continents. He made brochures with pictures of his work and mailed them widely. He handed them to people wherever he went—even on the street. He went frequently to Moscow. He went to the Baltic states. He made geological field trips. He gave his promotional packets to diplomats and foreign correspondents. "Most

of the artists had never even thought of such a thing," Dodge says. "Rukhin not only thought of it—he did it."

On the ninth of December, on six consecutive wedding anniversaries, Rukhin and Galina Popova gave parties in their apartment for as many as a hundred and fifty guests. Some came from Moscow, including people from embassies. There were waitresses in uniform. The grand piano was covered with bottles of vodka, wines, champagne; the eighteenth-century dining table with Galina's salads and roasts. On the walls, art hung in exhibition, for the most part the work of their friends.

Rukhin had an old Volga, which he drove back and forth to Moscow with paintings. He sold to embassy people more than to anyone else. "He had all the social skills," Melamid continues. "He was not afraid. He spent time in high-rises that were exclusively for foreigners. Was he supposed to be there? Of course not." For a time, he went to Moscow once a month for ten days. In summer, Galina rented a cousin's dacha in Peredelkino. Rukhin painted in the back yard. He became so negotiable that he inspired a genre of art even more underground than his own—the unofficial fake Rukhin. Norton Dodge says, "I think I may have two." There are fake Shvartsmans, fake Zverevs, in various parts of the world. Not to mention Maryland. It was against the law for Russians to have foreign currency. Rukhin had a lot of foreign currency. He was rich.

Under Article 76-1 of the Russian Soviet Federated

Socialist Republic Criminal Code, a Soviet citizen could be prosecuted for any contact with foreigners. Flagrantly, Rukhin opened his home to them. "Zhenya lived a free life," one of his friends has said. And another adds, "Rukhin was fearless. He was very diplomatic and elegant and handsome. He was really talented. Without training, he discovered a style. He was not afraid to invite diplomats to his place. They were always hanging around. He was our link to the West." Rukhin liked to say that he never paid his phone bill but very much doubted that the service would be interrupted because the phone was bugged and the K.G.B. was listening.

Rukhin always appeared at the Fourth of July party at the United States Embassy in Moscow. He was a guest of the diplomats in their quarters. He called the Mexican ambassador "Tortillas." For the diplomats, getting to know the unofficial artists was, as Dodge puts it, "an avenue into real Russian life—the artists were among the few links that embassy people could have with Russian people." By 1965, Dodge's leads to underground artists were, in fact, coming mostly from diplomats. Among the personnel in the American embassy, of course, were functionaries from numerous federal agencies, including Central Intelligence. There were C.I.A. people who were avid customers of Rukhin.

At Cremona Farm one time, I asked Dodge why C.I.A. people would have been interested in collecting Rukhin's work. "He was very charismatic in his person-

ality as well as doing interesting art," Dodge answered.

I said, "The C.I.A. doesn't go around looking for charismatic people."

Dodge said, "They may have been bored."

In Leningrad, a graduate student from Harvard, discerning the possibility of supplemental funds, dressed Russian and stationed himself with a stack of canvases beside the Neva. To passing diplomats and other aliens he whispered, "Deese-ee-dent, deese-ee-dent." He pointed to his gathered works. How many unofficial paintings from that era relate to Red Square and how many to Harvard Square is irretrievable knowledge.

Unsurprisingly, what proved most popular with the foreign market were unofficial paintings that thematically represented some aspect of the Soviet regime, or, at least, reflected past or present Russian life. Sitnikov's many kremlins were frankly aimed at the diplomatic and foreign-correspondent markets. Ilya Glazunov's cute Russian landscapes and portraits of czars were much in demand. Glazunov was among the first to break into the diplomatic community to sell. As Elena Kornetchuk says of him, "He was the darling of Russians because he was freeing them, making them feel like Russians, not Commies—heavy-duty diplomats gobbled up his churches."

Victor Tupitsyn and his wife, Margarita, an art historian, say that the diplomats they met in those years did not know art from wallpaper. They say that when

diplomats bought paintings they might as well have been buying *matryoshkas*—the nesting wooden dolls that were always popular with foreigners as souvenirs.

To the unofficial artists, the diplomats and correspondents were not just customers but were also a form of protective insurance. An artist who had such friends could expect that they would raise a clamor if the artist was arrested. The concomitant liability, of course, was that an artist could lose privilege as a result of contact with diplomats. Galina Popova recalls a visit that she and Rukhin made to the home of an ambassador in Moscow, and, afterward, a lift to the airport in the ambassador's car. She presumes that the driver was K.G.B. It happened that on the following day she presented to an art institute an essay on stained glass as a part of her application for a place in the institute. She had passed all preceding examinations with A's. Now she was asked, "Did you write about the role of the Soviet Union in the origination of stained glass?"

She answered, "There was none."

The questioner said, "A person of this political view cannot be accepted in the institute."

By the mid-seventies, Rukhin had made himself— after Glazunov—the best-known Russian artist in the United States and elsewhere in the West. Enough of his work got out of the country to be gathered into shows at the North Carolina Museum of Art and the Phillips Collection in the District of Columbia, while Rukhin

himself was in Leningrad and was not permitted to travel abroad. There were shows in Venezuela, Argentina. Reflectively, Dodge says, "He would have developed into an international artist of the first order." And again, "That is probably why they killed him."

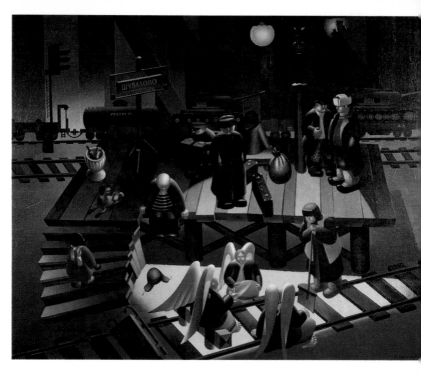

Vladimir Ovchinnikov, *Shuvalovo Station*, 1978. Oil on canvas. 43¼ × 55⅛ in.

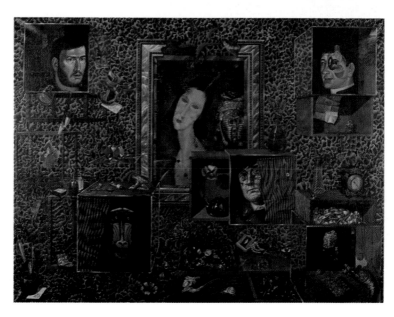

Igor Tiulpanov, *Memory Chests*, 1973. Oil on canvas. 46 × 62¼ in.

Leonhard Lapin, *Woman-Machine X*, 1975. Stereotype print.
15½ × 14¾ in.

Tonis Vint, *Girl in Circle*, 1975. Lithograph. 18⅛ in. diameter

Oleg Tselkov, *Golgotha*, 1977. Oil on canvas. 96½ × 75 in.

Dodge, of course, was more than involved in the
Rukhin shows in America, as he was in exhibiting the
work of other unofficial artists. From the point of view
of the Soviet regime, he was supporting political dissi-
dents, not only by purchasing their work but—worse—by
exposing it in the West. Now, in the middle seventies,
he was intensely expanding his collection, making fre-
quent trips. His scholarship in Soviet economics no
longer took priority. He set it aside in favor of aggressive
acquisition. Instead of applying for a visa for some sort
of academic purpose, he signed up for package tours
in the Soviet Union—tours organized by the Smithso-
nian Institution, Duke University, the International
Museum Association, whatever. In buses, the tour
groups visited museums, palaces, operas, ballets. Dodge
did not go. He just slipped away. "One was theoretically
expected to attend. I would simply not attend. I would

presumably be on one of the buses. I wouldn't be. This would get noticed after a while. It would become very noticeable to the people in charge. I was sometimes told that if I didn't shape up they might have to report that they had a wild card here. I stood out like a sore thumb. I'd be the only one who didn't go to see the Kremlin. I'd seen the Kremlin—in 1955."

A guide would say, "You haven't been coming along to the museums. If you don't start coming along on our bus trips, we're going to have to report you."

Dodge, looking blameless behind his storybook mustache, would reply pleasantly, "O.K., I'll come tomorrow. Thanks for letting me know. I hope you don't say anything."

With his increased sophistication in making contacts, he was able to lighten his dependence on embassy people, and a wise move that was: "If you got too involved with the embassy people, you were going to get harassed by the K.G.B., quizzing you—why you went here, why you went there. I had to make contact beyond the embassy circle to get into the parts of the Russian art world that were a little bit leery of embassy people."

In this city and that, after the buses returned to the hotels, Dodge would come back, freelance, with art tucked under his arm. ("I might have it rolled up in some posters glorifying Lenin and the latest five-year plan.") His wife, Nancy, who did not know him then, marvels at the incongruity of this story. "I've never had anybody pester me so constantly," she says. " 'How do

we get there? Where do we go now?' How in the world
did he ever get around? The minute he's with somebody
else he starts leaning. He can't fight his way out of a
paper bag. He's very dependent on other people to
help him do everything. He doesn't remember names,
phone numbers. He's very efficient at getting other
people to help him. He's half helpless and half in
command."

He tended to lean in the direction of women.
Divorced in 1970, he did not marry Nancy until 1980,
but is said meanwhile to have "thought of himself as a
ladies' man." He travelled with the evidence. In the
Soviet Union in the middle seventies, when he appeared
in apartments in Leningrad, Tallinn, Tbilisi, Samar-
kand, he was often accompanied by attractive women.
Galina Popova remembers Dodge with "a beautiful
Jewish paleontologist, nineteen or twenty years old,
really striking." His approach to women was no longer
professional. The book on women in the Soviet econ-
omy was nearly a decade behind him, as was a more re-
cent volume entitled "Economic Discrimination Against
Women in the United States" (with Robert Tsuchigane;
Heath & Co., 1974). He has been described by a woman
who knew him in Russia as "traditional in his relation-
ships with women," and what they discerned beneath
his glistening dome and behind his great billow of lip
hair and within his rumpled clothes would be for them,
severally, to report. One woman has told me that when
she was to meet him she was told to "watch for a guy

to come in with food all over his tie." Sarah Burke, who has known him East and West, mentions the same image. "Norton could indeed pass for a Russian," she says. "He is sort of unkempt—the food on the tie, the old broken-down raincoat. You expect to find socks in his refrigerator. He always looked shabby enough not to be arrested." She adds: "He liked to hear about Rukhin's flamboyant lifestyle. There's a certain voyeurism in Norton."

Galina Popova, widow of Rukhin, evokes Dodge as she knew him in Leningrad: "His determination, his excitement, his concentrated purpose—he knew what he was doing. There was a romantic air around him. He reminded me of a walrus. A big camera on his belly. Fast-moving. Live. We spoke English. He didn't demonstrate too much Russian at that time, although his Russian pronunciation is good."

"His Russian is far from perfect," a Russian artist confirms. And this hampered his mission, especially in republic capitals when he was trying to find an artist on his own, when there were no phone books and all he had was a name. You could call an information number, but with his accent he didn't want to do that, and he failed. Elena Kornetchuk, who was abroad with him in 1976, generously remembers that Dodge's Russian was by then "pretty good," but she also tells a story of Dodge in Munich, spending an evening with her parents, who lived there. Her mother was German, her father, a defector, a former colonel in the Red Army. The family

parakeet looked on as Elena's mother prepared blini with caviar that Dodge had brought from Moscow and her father tried to engage him in conversation. Dodge apologized for his poor Russian. In perfect Russian, the parakeet said, "Yes, why don't you shut up?"

Dodge met Melamid and his partner, Vitaly Komar, through Tania Kolodzei. She was an art historian by training. As a collector herself, she was developing one of the most extensive collections of unofficial art inside the Soviet Union. She had been married to Leonid Talochkin, a major collector, and also to an Australian art historian. When Dodge first knew her, in 1974, she did not want her connections with foreigners to be known. He did his best to be circumspect. Her job ended after lunch. He would meet her at or near her apartment, and they would visit one artist after another, often continuing until the wee hours of the morning, somewhere in the outskirts of Moscow, while the other members of his tour were asleep in the hotel. Through Tania Kolodzei he met Shteinberg, Pivovarov, Kabakov. He met at least two dozen of the more important figures—people he calls "the crucial Moscow artists." It was she who took him to the apartment on Leninsky Prospekt where Komar and Melamid worked together. They were in the forefront of conceptual art as it developed in the Soviet Union, and of the satirical Sotsart as well. Remembering Dodge's tastes and choices and apparent predilections in those days, Melamid says, "He came to this as an historian, not as an art connois-

seur. People in the West say of our art, 'It's total garbage.' People in Russia say, 'This is garbage. This is great.' None of us believed in Russian art as a whole. Everyone in Russian art knows Norton as a passionate collector. What is his motive? Why does he collect art? Why does he drop things on the floor? Why does he have that huge mustache? It's him."

As Dodge's network expanded, it consisted not only of additional artists but of additional intermediary figures like Kolodzei. In Leningrad, the figure was Kuzminsky, who put on exhibits in his apartment and led a sort of personal academy of freethinkers and was a focal point for the gathering together of writers, artists, musicians, and poets—the post-Stalin avant-garde. Needless to say, Kuzminsky was often in trouble with the regime. At a clandestine show in his apartment in 1974, the work of twenty-three artists was exhibited on twenty-four square metres. A thousand visitors came within a single week.

Dodge met Kuzminsky in the studio of Yuri Zharkikh, whose ominous figures and mystical connotations seemed to reach down through Russian Orthodox religion and into more primitive strata. Kuzminsky, Zharkikh, and Rukhin were among Leningrad's principal dissidents. By Kuzminsky's description, "If Zharkikh was the brain center of the situation, Rukhin was the heart." Kuzminsky gave Dodge material on at least fifty artists. He introduced him to Evgeny Mikhnov-Voitenko, whose gouache abstractions were uncannily suffused

with strong spiritual content. Mikhnov-Voitenko was a storybook Russian with long black hair and a long beard and a face that looked weathered from without and within. Kuzminsky said of him that he was "a terrible alcoholic but a genius." Dodge reached for his rubles. He found Mikhnov-Voitenko living in a small room with his mother and his wife in a multifamily apartment.

Kuzminsky put Dodge in touch with Igor Tiulpanov, some of whose best work Dodge would acquire. Kuzminsky recalls Tiulpanov as "a sort of monk," and goes on to say, "He painted a twenty-four-inch canvas with a one-hair brush, making jewelry out of art. In one day, he could cover an area the size of a fingernail. He sharpened a pen until its point was like a needle, and then he *drew* tiny dots. He worked like a goldsmith. He played tennis afterward, to free the muscles." Tiulpanov's work, large by Russian standards, was stored entirely in the very small room (fourteen square metres) that he shared with his wife. Surreal, complex, crammed with portraiture, landscape, still lifes, and bizarre animals within a single composition, his work, in Dodge's description, had "finesse reminiscent of the Renaissance." Tiulpanov would spend a year on one canvas. A piece might take three years if he was using the one-hair brush. His work is Russian to the backing —but it does seem to come from a dream vision that discovers Salvador Dali in quattrocento Florence.

Kuzminsky says that Norton Dodge was the first American collector to appear in postwar Leningrad.

Thinking for a time that he would extract and publish unofficial art in the form of photographs, he did some of his earliest collecting with a Polaroid camera, and from a Russian point of view it did not do much of a job. Tiulpanov gave Dodge slides. Kuzminsky continues, "Where all Americans would then give Marlboros, cigarette lighters, or some such, Norton asked, 'What did these pictures cost you?' Tiulpanov said, 'Twenty-five rubles.' Norton took out his old wallet and counted twenty-five rubles. I was knocked down. That attitude made him a friend."

As almost everyone else does, Kuzminsky likens Dodge to a walrus. It would be a feat not to. "An awkward, funny walrus—generous, kind, obviously friendly. He radiated interest not in the art as much as the situation—the life level—of the artist. He was lucky to meet the proper people in the proper places. With his taste and interest, Norton in Leningrad managed to get all the best. In Moscow, he found the best, too. Same in Baltic and Caucasian republics."

Rukhin led Dodge to Leonid Borisov, whose architectonic abstractions referred to the Constructivist twenties, and to Vladimir Ovchinnikov, who did "thick-bodied robust figures that reflected the vicissitudes of life in Russia." The description is Dodge's. Ovchinnikov's figures and settings were drawn with exceptional clarity. In his middle thirties, he was dark-haired and dark-eyed and could more easily have been taken for a woodcutter than for an artist. He lived in woods with a

woodstove. He painted overweight women playing vol-
leyball with a torn net on a collective farm. One post
of the net seemed to be a rocket. He painted a group
of people selling a handful of vegetables from a big
table in a market. He painted women with wings, evi-
dently angel wings, working on the repair of railroad
tracks. This canvas, like the others, found its way to
Maryland. "Women often did the heaviest work—work-
ing on the tracks, or laying macadam, sweeping the
streets—while the men stood by, supervising," Dodge
once explained, looking over the canvas after pulling it
from a bin. "He has women working on the tracks and
the station platform, a drunk and other people on the
platform, a tank car nearby marked BEER, military tanks
on a flatcar: excessive military concern, ever-present
militiamen, alcoholism, and overworked women, all in
one painting."

In Moscow, the photographer Vladimir Sychev, a
collector and exhibitor of art, led Dodge to something
like a hundred acquisitions, many in his own apartment,
where he kept rotating exhibits. Sychev's wife was the
daughter of a K.G.B. general. Dodge never felt quite
at home. Eventually, he learned that Sychev was under
surveillance, probably on orders from his father-in-
law.

At the end of a trip to Armenia in 1974, Dodge
found that he was short of rubles. He promised sev-
eral Armenian artists that would send jeans and
phonograph records as a way of paying for works of

art. In Moscow, not wishing to risk the Armenian addresses in any kind of search, he entrusted them, in his words, "to someone who was supposed to get them out for me safely." At the airport, as he had feared, all his notes, address books, and other written records were removed from his suitcase and copied. In his distinctive way, he had openly written names, phone numbers, and so forth, where others would have written codes.

The Armenian addresses, presumably safe, never followed him to America. A year or so later, a letter came from Paris signed Garig Basmadjian—a name unknown to Dodge. Basmadjian said he was authorized to collect for the Armenian painters. Dodge, relieved and delighted, sent a check by return mail. The stranger wrote again, to say that he had fifty Armenian dissident paintings in Paris, and he included prints. Into the dark, Dodge shot ten thousand dollars for nine or ten of the pictures in the prints. A crate soon arrived at Cremona Farm. In years that followed, Garig Basmadjian was Dodge's principal intermediary in Armenia—until, in an event quite possibly unrelated to this narrative, he disappeared from a hotel in Moscow, never to be seen again.

The Smithsonian tours included Tallinn, and while the other tourists were in the House of the Brotherhood of Blackheads or viewing the Kiek-in-de-Kok in the Fortress Wall, Dodge was persona non present. In their apartments, Estonians had Dutch beer, English whisky,

Danish crackers, American cigarettes, and Swedish sexual magazines. Kuzminsky, who provided Dodge with introductions to the unofficial artists there, says that "in the center of Soviet Tallinn they had their sort of tiny freedom, but they were warned: No contacts with Moscow or Leningrad." Let alone Maryland. "The government didn't want the wind of freedom that was blowing in the Baltic states to penetrate Russia," Kuzminsky continues. "The layer of bohemian artists was very thin there. It was easy to have two or three informers and know everything." Baltic artists were masters of ambiguity—a sort of group deception of Moscow. The line between the official and the unofficial was a good deal less distinct there. The artists were more free. They kept a certain national identity, which insulated them to some extent from Moscow's interference. But there were limits to how far they could go in public exhibits. The first people Dodge called on—who led him to large numbers of other Baltic painters—were Leonhard Lapin and Tonis Vint. Lapin mixed nudity and machinery to produce, among other things, a sexual energy of sufficient charge to be regarded by a Moscow censor—or even a Forty-second Street newsdealer—as pornography. Something resembling a stick shift enters the pelvic core of a sensuous transmission with breasts and open legs. "This would be total anathema to the regime," Dodge says mildly. "Even in Estonia, they could not conceivably show this kind of thing." They showed Dodge, and he bought it.

In a couple of dozen compressed words, Kuzminsky sketches Vint, describes the peculiarity of Estonian artists under Soviet rule, and outlines Vint's thematic qualities: "Vint, his hair to his waist, an official artist —imagine! Vint, painting a black square, with a carefully drawn cunt in each corner!" Dodge on Vint is more exploratory: "Vint's work involved an approach to women not totally unrelated to Lapin's, using a sort of Beardsley style, black and white. Vint would counter-pose voluptuous gorgeous women with geometric designs—exploiting the conflict of inhuman linear geometric designs versus the rounded full-bodied women." When Vint was asked to illustrate a Young Communist League publication, he used a circle as the main geometric feature. In it—eccentric, left—was a young nude lounging on propped elbows, her legs somewhat spread, her pubic hair presented. The regime printed thirty-six thousand copies before censors saw *Girl in Circle* and suppressed the publication. "Vint was one of the key leaders of nonconformist artists in Estonia," Dodge continues. "He helped edit the magazine *Kunst*, and also taught young people avant-garde approaches to art. Among them was Siim-Tanel Annus, who was only sixteen at the time, and was already doing extremely interesting pen-and-ink drawings. I acquired a few." He acquired more than a few prints by Malle Leis, who has been described critically as having a "feministic approach to decorative flower painting." She could make even a fresh blossom look pensive and somber. Her

portraits project vacantness, emptiness—the reaction of Estonians to the situation that the Russians had thrust them into. He bought the work of Raul Meel, an Estonian engineer with no formal art training. Meel's early work appeared to have been generated from an architect's blueprint. Later, he incorporated maps of Estonia. In one series, bloody handprints covered the maps. Even by the Baltic, that was worse than pornography.

In 1976, Dodge fell into conversation in the airport in Vienna with a man who turned out to be Paul Sjeklocha. Both were waiting for a flight to Moscow that was delayed overnight by heavy weather. Dodge describes Sjeklocha as an American of Yugoslav origin who did weapons trading in the Middle East, and also dealt in Soviet pharmaceuticals repackaged for the West, and was also a co-author of "Unofficial Art in the Soviet Union" (University of California, 1967), which Dodge had read, and was also a hunting guide who took high-paying clients into Soviet Central Asia. Waiting for the plane in Vienna, Sjeklocha was on his way to a hunt in the Caucasus. He had his rifle with him, and a hundred rounds. In Moscow, as they went through customs, no one looked in Sjeklocha's suitcase. A couple of days later, Dodge went to see Sjeklocha in the Hotel Rossiya at the edge of Red Square. Sjeklocha's room overlooked St. Basil's Cathedral and the Kremlin and had an open view of the Spassky Gate, through which the members of the Politburo passed in their

[*67*]

limousines every morning. To Dodge, this was an un-
usual photo opportunity, and he remarked on it. Sjek-
locha said, "Yeah. And that's the Spassky Gate, through
which the Politburo goes. I could sight-in my gun here
and when they come I could pick them off." Dodge
began miming alarums and waving at the ceiling and
the light fixtures. "Don't worry," Sjeklocha said. "The
more outrageous you are, the less they know how to
deal with you."

From Sjeklocha's book, Dodge had learned about
artists he didn't know. From Dodge, Sjeklocha learned
about many artists he didn't know—an indication of
the continuing spread and secrecy of unofficial painting
in those late-middle Brezhnev years. Not long after they
met, Sjeklocha vanished. He was held in Lubyanka by
the K.G.B. until he was traded to Washington for
Russian spies. Some years after the trade, he returned
to Russia. He lives today on the Sea of Okhotsk, in the
oblast of Magadan.

Sjeklocha's disappearance was in a common genre
that had long haunted Norton Dodge. Across his years
of travel in the Soviet Union, he was made increasingly
skittish by each new tale of a traveller swept off to
prison. Frederick Barghoorn, a Yale professor, was
about to leave the Soviet Union after a visit in the sixties
when someone thrust a sheaf of papers into his hands
and he was arrested by the K.G.B. seconds later for
"the attempted smuggling of an anti-Soviet manuscript."
After a few weeks in Lubyanka, he was traded for

Russian spies. A professor of Russian language and history from Holborn College, in London, carried with him to the Soviet Union, at the request of a contact there, a packet of printed materials unflattering to the Soviet regime. The contact had set him up for the K.G.B. He spent that first night in Moscow in Lubyanka. He spent five months in Lubyanka and other Moscow prisons. While the Soviets kept trying to trade him for Russian spies, he spent seven additional months imprisoned in Vladimir and three years in a labor camp on the Volga steppe. His name was Gerald Brooke. After the trade at last occurred, Brooke made a visit to America. An American scholar happened to take him to Cremona Farm, where Dodge learned his story.

In the nineteen-fifties, Dodge had contributed a chapter on Soviet labor, including forced labor, to a book published by the Munich-based Institute for the Study of the U.S.S.R., which was supposedly subsidized by an American nonprofit organization. When Dodge tried to make a private contribution to help the cause, the institute declined it, explaining that all the money it needed was being supplied by various American corporations. "Later it was revealed that the corporations were all fronts, and the whole thing was a C.I.A. operation," Dodge continues. "So therefore I was obviously involved in the C.I.A. at least as much or more than Barghoorn, and I felt that if any time the Russians wanted to fabricate a case against me they could. At

any rate, I began to think they were noticing. That's why I began to get cold feet. As I kept going back repeatedly, my dossier was getting fatter, or so I imagined. I figured it's like this Italian who got involved in unofficial art way back in the sixties. And he made twenty-two trips before he sort of became persona non grata and never went back again. He got cold feet, too. After I heard about friends of people that I knew being picked up for trading purposes, I didn't want to expose myself unduly to risk. I used to always think that the embassy people were overly paranoid, but in fact I became more and more paranoid myself about what might happen if I kept going back."

In Kiev, on one tour, he was in conversation with another American professor when they were interrupted by heavy knocking on the door. Two hulking figures entered the room, and Dodge supposed that he was on his way to prison. The hulking Ukrainians threw their arms around the other professor. He was their lost cousin.

Always, Dodge became very anxious as the time drew near for going home. He was searched more thoroughly each time he left. ("It was best not to have the art with you, if you had some other way of getting it out.") Meanwhile, travelling on trains, he just propped things up in corners. "People would assume you had bought a poster. The upper size limit was thus three or four feet and a rolled diameter of four or five inches. I couldn't carry orgamite, the Soviet version of Masonite.

Kabakov's albums, twenty inches by twelve or fourteen, could be carried under one's arm and would look like a book. His major paintings were six feet high and ten feet long. There was no way of dealing with those myself. You never knew when something awkward to deal with would happen. As I travelled around, I always had to carry whatever art I picked up on to the next place, which might be Kiev, Odessa, Tbilisi, Yerevan, and then from Yerevan back to Moscow. I'd be going into various hotels with somewhat obscured rolls of paintings, or works on paper, and stashing them where I hoped they weren't obvious; but you never could tell who would be coming in and poking around in your hotel room. On a number of occasions, I would find evidence of people getting into my suitcase. On one occasion, I found that someone investigating a suitcase had unfortunately locked it and I had no key. That left me having to pick the lock to my own suitcase. There were things in it that I was not hopeful that the K.G.B. would find, like all sorts of letters, notes. I don't think I had any art in that suitcase. I thought if the investigator went that far he might have found works in the closet under my coat. I picked the lock with a penknife and a paper clip."

Asked if Dodge was in physical danger, Kuzminsky replies, "I think he was. Especially in Estonia. Once, he went there with Rukhin and others and Natalia, my secretary, who was an informer; I learned it only ten years later. She was a nice girl and good for sex, but

she was working for the K.G.B. Not only were they followed there, they had Natalia with them. Also, of the fifty-five artists in Tallinn, ten percent were informers."

In Moscow one day, Dodge made a call to an artist from a public telephone between the K.G.B. headquarters and Detsky Mir, the children's department store. Leaving the phone booth, he went on to Detsky Mir to shop for gifts. A young man in a dark coat came up behind him as he was going into the store and tapped his shoulder. Dodge tightened, sure that the man was "a K.G.B. tail." The man said, "Are you the person who just used the phone booth?"

Recklessly, Dodge said, "Yes."

"Did you leave this?"

In his hand was Dodge's notebook, which contained the names, addresses, and phone numbers of everyone he knew in Moscow, everyone he had seen or was going to see in the Soviet Union. What happened next might have been an arrest, but the young man was not a K.G.B. tail.

Minas Avetissian, untitled, 1961. Oil on canvas. 13¼ × 19 in.

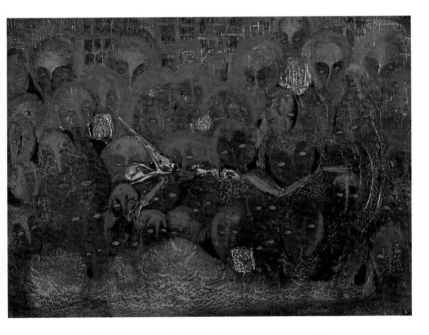

Yuri Zharkikh, *Anticipation*, 1977. Oil on canvas. 20⅛ × 28⅜ in.

Leonid Lamm, *Exercise Yard, Butyrka Prison*, 1975. Watercolor and ink on paper.
22 × 15 in.

Dodge's fears were optional. He could stay home. The artists' fears were not optional. Alexander Melamid speaks for them: "We were scared to death. All of us. The K.G.B. was watching us. It's like in the United States: people constantly taking vitamins and exercising under constant threat of death. We were under threat from the K.G.B.—constant fear that the K.G.B. was around the corner, listening."

The artists' crimes were chronic and innumerable. They went on committing social parasitism, committing abstract expressionism. Abstraction was lawful only in decorative art, graphic art, but not in painting. Craftily, Nemukhin joined the Graphic Artists Union. Of the artists' so-called dissidence, Galina Popova says, "They didn't do anything. It was just art. Their crime was that they gave art to foreigners to export for exhibition." Dodge picks up this theme: "They wanted to create

without feeling that it was necessarily an expression against the regime. In other words, they weren't necessarily anti-regime artists in a political sense, but in fact, given the totalitarian thought-control aspects of the Marxist-Leninist philosophy, anybody who didn't fit into the framework that was dictated by the government was in effect considered against the government. So whether they themselves really felt anti-government or not, the government felt they were. So they often found themselves in positions they never anticipated being in —willy-nilly cast in the role of enemies of the state."

The political climate stirred up an intense collegiality among the unofficial artists, which the government tried to break up. Or, as a C.I.A. employee from those years has described them: "There was a time when anyone who got involved in the arty world—artists, writers, refuseniks—drew the attention of the K.G.B., who were interested in smothering dissident activity." The K.G.B. kept constant surveillance on artists' apartments. The artists committed an offense if they lingered in cities other than their own. To keep groups of many kinds from expanding, there was a Soviet rule that a citizen away from home could stay in a city only three days.

Pressure was more severe at one time than another. Under Andropov and Chernenko, just before Gorbachev, the harassment of artists became more drastic than it had been even in the sixties and seventies under Khrushchev and Brezhnev, when the K.G.B. may have

been preoccupied by the steady defection of the written word. Not that Khrushchev dreamed of new frontiers in art, as he proved at the internationally reported exhibition at the Manezh, former royal stables, in 1962, where the Artists Union, which was celebrating thirty years of Socialist Realism by exhibiting two thousand canvases, permitted some "new art" by young painters to be hung in separate rooms. The First Secretary agreed to have a look. While the Union's declared objective in asking him to be there was to win his approval of the new art, there were those who saw a conservative stratagem to arouse in Khrushchev a predictable rage. In any case, that is what happened, as the world soon knew. Viewing some of the work of what would prove to be the developing underground, Nikita Sergeyevich stopped before one canvas and said, "Who painted this picture? I want to talk to him. What's the good of a picture like this? To cover urinals with?"

The young Boris Zhutovsky stepped forth to be berated.

Khrushchev said, "You're a nice-looking lad, but how could you paint something like this? We should take down your pants and set you down in a clump of nettles until you understand your mistakes. You should be ashamed. Are you a pederast or a normal man?" In further appreciation of Zhutovsky's work, Khrushchev said, "We aren't going to spend a kopeck on this dog shit. We have the right to send you out to cut trees until

you've paid back the money the state has spent on you. The people and government have taken a lot of trouble with you, and you pay them back with this shit."

Referring to another painting he had seen, Khrushchev said, "It consisted of some messy yellow lines which looked, if you will excuse me, as though some child had done his business on the canvas when his mother was away and then spread it around with his hands." And encapsulating his impressions he said, "People tell me that I am behind the times and don't realize it, that our contemporary artists will be appreciated in a hundred years. Well, I don't know what will happen in a hundred years, but now we have to adopt a definite policy in art . . . We won't spare a kopeck of government money for any artistic daubing . . . As long as I am president of the Council of Ministers, we are going to support a genuine art. We aren't going to give a kopeck for pictures painted by jackasses."

Before Zhutovsky's essentially unidentifiable "self-portrait," Khrushchev said to the artist, "You are stealing from society. You are a parasite. We have to organize our society so that it will be clear who is useful and who is useless. What right do you have to live in an apartment built by genuine people, one made of real materials?"

The artist said, "These are just experiments. They help us develop."

Khrushchev said, "Judging by these experiments, I am entitled to think that you are pederasts, and for that you can get ten years. You've gone out of your

minds, and now you want to deflect us from the proper course. No, you won't get away with it . . . Gentlemen, we are declaring war on you."

According to Priscilla Johnson and Leopold Labedz in "Khrushchev and the Arts" (M.I.T., 1965), his remarks at the Manezh "proved to be the signal for the most far-reaching crackdown on the creative arts in the Soviet Union since the Zhdanov purge of 1946–1948." Khrushchev had long since denounced Stalin. This was at the height of his "thaw."

The Comédie Française performed in Leningrad about then and the unofficial artist Rodion Gudzenko sold the company some of his paintings. He got ten years. Sashok Arefev, also of the Leningrad "Barracks School," was sent to both prison camp and mental hospital. The Barracks School included about a dozen painters. Six were put in camps. At one time and another, Barracks School artists were committed to twenty mental institutions.

The poet Kuzminsky, a friend of everybody in the Barracks School, later wrote a piece about them in *A-Ya*, the "Unofficial Russian Art Review." Kuzminsky has suggested that the painters were victims of informers, sometimes of their own kind. He names the wealthy Moscow artist Ilya Glazunov, describing him as "a definite agent of the K.G.B." Kuzminsky has told me, "The K.G.B. practiced on fighting dissidents just for fun. The K.G.B. gave me a second belly button. It happened in a friend's apartment on the night of

January 13–14, 1970. If a fight occurs between artists
and poets, we break the nose. But these are different.
These were professional karate blows—one to the
spleen, one to the intestines. Left. Right. Many times
they invaded our apartments just to make harassments."
Typical K.G.B. agents, as he describes them, were men
in their early twenties, in jackets and ties, not unlike
the young messiahs in the United States who hand out
pamphlets extolling cleaner-than-thou denominations.

In 1972, the studio of Minas Avetissian, in Yerevan,
burned up with about a hundred paintings in it. In
unofficial circles, he was an important painter who did
landscapes, mountains, village scenes in bright color.
His work is represented in the Dodge collection. His
death, at the age of forty-seven, occurred a couple of
years after his studio burned. His death was called a
"presumed accident."

In 1973, the K.G.B. called artists in to ask about
sodomistic parties and venereal disease. They men-
tioned psychological tests. Galina Popova says that in
actuality the K.G.B. was more put out by the presence
of foreign diplomats at the parties then by what occurred
on beds. Galina was pregnant that fall. When she went
in for a routine gynecological check, she was sent on to
a venereal-disease clinic. "They threatened to kill my
baby by injection," she claims. They said she would not
have to be injected if her husband were to come in
voluntarily. She called Rukhin. He said to her, "You
are strong enough to resist." A sympathetic doctor told

her plainly that the point of the injections was to harass Rukhin. She called him again, she says, and told him, "You have to come." He said, "You are the strong one. You will go through it. I cannot go." She went through some weeks of what proved to be harmless shots.

Also that fall, she attempted to gain acceptance into a Ph.D. program in Moscow. The vice president of the school she applied to closed all doors and said to her, "I'm an old man. Tell no one. You are turned down because of your husband. It was not my decision. It was instructions." Her daughter Lisa was born soon after the first of the year, and three weeks later, according to Galina, came "the first time our windows were cracked." Rukhin was in Moscow selling paintings. Lisa was in bed with Galina. There was one crash and then another—first a window in the living room and then a window in the bedroom. Glass in small pieces fell on mother and daughter. Instinctively, Galina pulled the baby to her, cutting herself and Lisa. She called the police. They came at once, she says, as if they were waiting. The baby tried to cry. Her mouth was filled with blood. The policeman, smiling, asked, "Are you alone in this beautiful place?" A chunk of granite had scarred the piano and fallen to the floor. "Hooligans," the policeman said, and he left. She was in darkness, of course, because there was no electricity after 2 a.m. Another rock came through a window and hit the piano. She tried to use the phone to call a friend. The phone was dead. Next day, she continues, she called Rukhin

in Moscow. He said, "I cannot help you. You are strong enough to handle this."

In September, 1974, a small group of unofficial artists, including Rukhin, Zharkikh, Rabin, Masterkova, and Nemukhin, planned to use a vacant field on the fringes of Moscow for a one-day exhibition. This became the globally renowned "bulldozer show." The artists slept the night before in the apartments of Rabin and of Victor and Margarita Tupitsyn. They were fewer than a dozen. They limited themselves to two paintings each. In the morning, carrying easels and canvases, they converged on the field. They had put out word of what they meant to do—it was, after all, a show—but not, they hoped, too much word. They might have known better. The artists were tidy, neat, conformably dressed in suits and ties. Walking around the field were other people wearing suits and ties, whom the artists did not know. Close by the field were several water trucks, and workmen who said they had come to plant trees. From the trucks, high-pressure hoses were turned on the artists. A bulldozer came onto the field, its tracks turning at full speed, throwing mud. Suddenly, Oskar Rabin was tugging at a painting that was under the dozer's blade. A number of artists fled. The Tupitsyns remember Rukhin for his courage that day. Victor has said, "I remember him fighting with K.G.B. people on the field, not fearing. They started smashing paintings. They broke them over their knees. Actually, they were all wearing civil clothes. No telling who were K.G.B. and

who were police people." Galina Popova hit someone with an easel. Rukhin and Rabin jumped onto the blade of the bulldozer and rode on it dangerously for some distance. Rukhin, when arrested, refused to walk. He was carried off the field.

In the police station, one of the plainclothes officers said to him, "I don't want to know what you are doing but I wouldn't hesitate to shoot you."

Rukhin said, "Why? You don't know me."

The man said, "I don't need to know you."

A man in a beret said to Galina that she had wounded him with the easel.

"Show me," she said.

He said, "I don't need to show you. You—an official artist—how can you accompany these hooligans to this event?"

She said, "Who are you—an art critic?"

The artists found deliverance, in a sense, in the fact that they had such extensive connections with foreign diplomats and correspondents, for there was a din of outrage in the Western press of sufficient magnitude not only to help protect them but also to cause the Soviet government to permit a follow-up exhibition two weeks later in Izmailovo Park. This milestone seemed to be a major step toward the liberation of unofficial art. It wasn't.

Witness the feet of Yuri Zharkikh. Rukhin and Zharkikh were the unofficial organizers of unofficial art exhibits in Leningrad. Zharkikh, whom Kuzminsky de-

scribed as "the brain center" of the dissident artists there, the "best leader," made frequent trips by train to Moscow. Nine months or so after the bulldozer exhibit, he was in one of four bunks in a sleeping compartment in a train en route to Leningrad when someone evidently slid open the compartment door and dropped a dry, pulverized, vesicant substance into his boots. His feet blistered within hours of his putting the boots on, and —reminding people of the effects of nitrogen-mustard gas in war—developed ulcers and burns so painful that he was crippled and in a hospital for several weeks. The episode had about the same effect as a posted notice—a warning, a sign.

A couple of months later, Rukhin returned from Moscow one evening, and, exhausted, was soon asleep in bed. In hours that followed, their doorbell rang repeatedly, and Galina ignored it. It rang again, though, and she opened the door. A man with a knife fell into the room, stumbling on a step he did not know was there. She screamed. The man jumped up and pinned her to a wall with the knife at her chest. Rukhin appeared, in Cambridge-blue Christian Dior pajamas. He grabbed the man's wrist with both hands, and as the two men struggled they went out through the door into high wind and wet snow. Rukhin overcame the intruder, who said to him, "Don't call the police. You will be sorry. My father is a colonel in the K.G.B." Rukhin called the police. The intruder turned out to be a criminal of record, who, Galina imagines, was sent

to harass them by the K.G.B. on a promise of leniency. When Evgeny and Galina were called in for questioning, a woman in a police uniform asserted that Galina had invited the man into the apartment.

Galina said, "What about the knife?"

The woman said, "Maybe he was sharpening a pencil."

Erik Bulatov, *Dangerous*, 1972–73. Oil on canvas. 43 × 43 in.

Josef Yakerson, *In the Midst of the Dead*, 1966. Oil on canvas.
97½ × 98½ in.

Semon Faibisovich, *At the Stop* (from the cycle *Moscow Suburban Electric Train*), 1985. Oil on fiberboard. 55 × 33½ in.

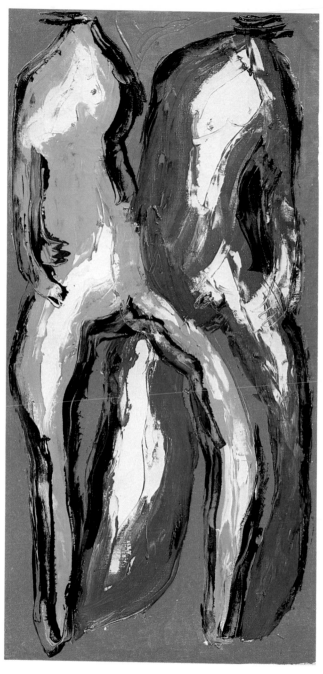

Ely Beliutin, *On the Street*, 1977. Oil on canvas. 51 × 25½ in.

To the question "What impelled Norton Dodge to run the risks he did in extricating so much unofficial art from the Soviet Union?" answers come in as many varieties as there are words in the question. Almost anyone hearing his story cannot help thinking that he could have been more than an economist collecting art and information. Anyone he met in the Soviet Union would have thought the same. In the words of one artist, "We never knew where he came from or where he was going, and we didn't show interest. Those were the rules. Everyone could have been an agent, including us, including Norton Dodge. Only now that it is past do we realize how strange and paranoid it was. There is no exaggeration in Orwell."

Did the K.G.B. know everything about him?

"No doubt about it. They were efficient. They threatened him enough so that he didn't come back."

A helping friend has passed along to me a hand-written note from a person I have been counselled to describe as "a reliable Soviet defector from the Second Chief Directorate of the K.G.B." (The mission of the Second Chief Directorate was the defense of Mother Russia. The First Chief Directorate did espionage overseas.) The K.G.B. defector writes, "I do not know Mr. Norton T. Dodge, but taking into account the supplied information about his trips to Russia I have serious suspicions. (1) The fact that the man is a specialist on Soviet economy. The K.G.B. was always paying special attentions to all American specialists on any field of Russia or Soviet Union from the beginning of a foreign tourism to the U.S.S.R. in 1955. By the way, the first recruitment by the K.G.B. of an American tourist was in 1956, who a professor of an American university—a specialist on Russian history. (2) The man visited the U.S.S.R. over 20 years (1955–1977) on many occasions. The K.G.B. was extremely suspicious to Americans who were coming second and time to the U.S.S.R. (3) The man on his trips to the U.S.S.R. was visiting unofficial artists in different cities throughout the U.S.S.R. (4) The Soviets were and still are very strict with any pieces of art going abroad."

Americans had suspicions, too, as Professor Sarah Burke reveals in discussing her own feintings and shiftings with the K.G.B.: "You tried to blend in with the population. You could be arrested. You could be walking down the street and a car would pull up. Almost

anything you did was illegal. It was a game. For me, it was like risky living. I was very cautious and very careful. Seeing artists was a reason for taking you and interrogating you. They thought everybody was a spy. They must have thought Norton was a spy. I thought Norton was a spy. Why? Because people his age who taught Russian subjects were connected somehow to the C.I.A. He's so bumbling. No one would think he was. His Russian is just ghastly. The flashlight cracked me up. Russians don't have flashlights. You just wouldn't do that—look for them with a flashlight. You'd meet somebody somewhere. Besides, you endear yourself to Russians if you're completely discreet."

To numerous people, in fact, Norton Dodge sounds so much like a spy that they find it almost impossible to believe that he was not. For his part, he dismisses the idea as romantic nonsense. Other sources, looked into, assert themselves dry. So you are left with an assemblage of story blocks and dotted lines, a write-it-yourself novel—"Burnt Norton"—in which he bumbles around Khrushchev's Soviet Union and Brezhnev's Soviet Union, first as an economist interested in tractors and women, and later as a tourist collecting and smuggling underground art. Creatively, you give him all that as developed cover, and try to imagine what he was doing as an operative (with flashlight) from the C.I.A. Or, you see him merely as an economist interested in clandestine art, female employment, and tractors. And, or, maybe—why not?—you see him as a double agent.

You tell your reader, "Either (1) the Soviet Union was a great deal easier to get around in than most of us imagined or (2) Norton was in the K.G.B." What is common to all plots you may construct, however, is that in the denouement the art comes out. Nine thousand works of art come out.

When he went to the Soviet Union in 1955, he had a sense of the stirrings already going on there in literature and poetry—stirrings that increased greatly, in the following year, after the Stalin-denunciation speech and the beginning of the relative thaw. Thinking about it, Dodge decided that if such things were happening in literature something analogous must be occurring in art: "You knew that since people had been writing for the drawer there must have been people who were painting for themselves and their friends." An article in *Life* mentioned unofficial artists, confirming his extrapolations, and the thought occurred to him that while "it was easy to smuggle poetry out, and novels, and manifestos, and to have conferences ad nauseam, in the art field there was a whole branch of the dissident or underground movement that wasn't visible here or being discussed here." Before he made his first women trip, in 1962, he had had further thoughts, which he recalls as follows: "It would be tragic if these artists were to die without their work being seen outside Russia. The courage of these people . . . They worked often in isolation with no audience other than their wives and families and a small circle of friends.

They risked harassment and interrogation. Also, I thought, if anything is going to happen to change the system for the better it had to be through greater freedom of expression. These people were sticking their necks out. They were risking everything."

He tried to interest, among others, the American Association for the Advancement of Slavic Studies, but essentially failed. The Western art world, in its various manifestations, seemed even more indifferent than the A.A.A.S.S. Asked why this would be so, Dodge delivers an analysis that ultimately fixes himself in the context and meanwhile sounds like one of his lectures on Soviet economics: "The nexus that is necessary for the development of an interest in some sort of art movement was missing. Much of the nexus is involved around the marketing of art, the buying and selling of art, the mechanism able to make the artist able to survive and produce. This did not exist in Russia. The Americans were not interested because art historians like dead artists, dealers want a steady supply, and critics review exhibits, they don't go off digging up artists. Museums don't collect artists unless they have been anointed by having many shows with good reviews. I felt it was left to an economist who goes to Russia. I thought, If anybody's going to do it I guess I'll have to do it. That's why I was first attracted. The people who should have been doing it weren't doing it; and I thought, If the right people aren't doing it, then who else but me?"

When he began his collecting, his friends the

MacDonalds at once understood what he was doing. Allen MacDonald used to leave copies of American magazines in Moscow subway cars so that people would pick them up and have them. "The Soviets wanted to hide everything, and they would use strong-arm stuff if they felt they needed to," Pete MacDonald has said. "Those of us not on the military side felt challenged to dig out anything they hid. With so much stifling of information and stifling of the human spirit, all of us felt a bond with the Russians and wanted to help them. We wanted to bring out the truth. Norton was in contact with the artists. He *knew* them. He felt that here was a whole creative force being bottled up, and he wanted to get it to the outside."

Dodge continues, "I started out thinking, I really don't care too much whether the art is good or bad. I just am interested in getting it out and then people will have something to form their judgment on. But I soon found I thought it was very good, much of it—although, surely, large parts of the collection aren't very good." Jon Showe, husband of the gallery owner Elena Kornetchuk, describes Dodge as having had a "holistic approach to art—more than the sum of the parts." Art collectors often specialize, he explains, "but Norton is broad gauge." The most important aspect of him as a collector of Soviet unofficial art "is Norton's appreciation of the milieu that gave rise to all this: someone else gets interested in a certain period in painting and goes and looks up the history, the political and economic and

social systems; Norton went at it the other way around."

Dodge told the artists that he wanted to collect the art so that at least some of it would be available somewhere no matter what happened to them or to their collections in the Soviet Union. He added that he was not just interested in collecting; he wanted the art to be publicly exhibited. The artists, for their part, seemed to yearn for Western validation. Touchingly, they even sought the opinions of embassy people, which may have been like seeking mariners' opinions of climbing routes in the Alps. Dodge was often embarrassed when the artists he sought out earnestly asked for comments. He would say, "It's very interesting. Very interesting, indeed." He was like an obstetrician saying, "Now there *is* a baby!"

Father Alipy, abbot of the monastery of Pskov-Pechersky, was collecting the work of unofficial artists in the same years that Dodge was. Father Alipy had been an artist himself. His collection of underground painting grew to include the work of several hundred artists. He died in 1975. Almost immediately, the monks of the monastery, in cooperation with the state, destroyed the collection.

Asked why Dodge did what he did, Victor Tupitsyn says, "To help this art be survived."

"To survive," Margarita Tupitsyn says, correcting him.

Victor: "To come to life. He is compassionate."

Margarita: "He sometimes feels first for the artist

and then for the art. You can't imagine how many Russian émigrés are surviving because of him. He supports them and their families."

Taking into account the fortune he spent for his collection, Dodge said, not long ago, "We didn't have children or expect to have children. It was not a matter of robbing any children or grandchildren. It was interesting to see your assets giving support to those who were undermining the monolithic thought-control apparatus of the Soviet Union. This was one factor among the many in the breakup." He would appear to have been a spy for the humanities. In a conversation I had with Elena Kornetchuk and Jon Showe, Kornetchuk said of Norton Dodge, "He's the Lorenzo de' Medici of Russian art."

Showe said, "A Maecenas."

Eduard Gorokhovsky, untitled, no date. Photo silkscreen/lithograph. Series of four, each 22⅞ × 14½ in.

מה נשתנה הלילה הזה מכל הלילות ?

Samuil Rubashkin, *Passover*, 1973. Oil on canvas. 39¼ × 31⅜ in.

Notes made one summer day that could have been made in any season:

On top of a small fire extinguisher on the kitchen wall at Cremona Farm are thirteen hats, hung there offhandedly, one upon another, each a sign of fresh arrival, each a distinct moment in epicranial time, as random and as ordered as any stratigraphy, and all belonging to Norton T. Dodge. One ignores, of course, the great formal portico and enters the house through the kitchen—a fairly large room, square, with a professional range, a countertopped island, a refrigerator six feet wide. There is topography in this kitchen—hills, valleys. Mail, for example, on the central island, appears to represent a wedge of time from the present backward two years. Spices in little unracked cans, enough for twenty farms. Bottles, boxes, bags in great profusion, contents half consumed. West of Anatolia, there may

be no bazaar denser than Dodge's kitchen. On a corner table is a heap of newspaper clippings and other printed materials that date back—riffling reveals—at least seven years. What is all that? One can't help asking. "Inert stuff that needs to be processed," the owner says. "Meanwhile, the cat lies on it." Posted on the door to the kitchen porch are many bulletins. One lists a hundred and fourteen bird species seen on Cremona Farm in a six-week period twenty years ago.

The kitchen porch is long, narrow, glassed-in, full of canoe paddles and climbing vines. The table where Dodge works and takes his meals requires plowing to get down to surfaces level enough for the meals. Within the eight-year-old stack on a second table is a blackboard eraser, a book called "Self Management and Efficiency —Large Corporations in Yugoslavia," a three-year-old *Washington Post*, and a seven-year-old letter signed "Vladimir Urban."

Nancy Dodge has said of her husband: "Norton is a collector in all respects. Books. Magazines. Art catalogues. It's like living with the Sorcerer's Apprentice. If you clear a place it fills right back up."

For Christmas, Norton has given her notes promising order, promising reform. He might as well promise a farm on the moon. Walter Deshler, vintner of Cremona wine, says, "The sweet bastard can't throw anything away. He is obsessive. Anal retentive. He'll never sort through the debris. When Norton departs this earth, his yard sale will be wild. Eternally, he sits at the kitchen-

porch table, with papers in front of him, saying, 'I'm behind.' "

He works there much of the day. Nancy says that with respect to exercise Norton's outer envelope is a one-way swim across the pool. His idea of a hike, she says, is to take two shopping bags full of books, and go off somewhere and read them. They have paddled fair distances, mainly in the Thousand Islands. With his father, Norton paddled down the Green and the Yampa and the Colorado through Glen Canyon when the dam was not there. "Papa was always in the stern," Nancy remarks. "Now Norton is in the stern."

He calls her each evening from a phone in the old pantry, on the way to the dining room. She works in Washington and is intermittent at Cremona. On the wall above the pantry telephone are posted notices dating back twenty years, far down into the time when he was travelling in the Soviet Union. Piles of papers, bottles, and cans are even more dense in the pantry than the kitchen. These include about a dozen plastic jugs for transporting Cremona well water to their apartment in the District of Columbia.

The dining room is the command post of Dodge's personal sorting, filing, processing, and retrieval system, which long ago achieved the level of terminal dysfunction. The dining room—with its tall draperies, its extended elegance, its marble fireplace—would not be amiss in a governor's mansion. One can almost see the gowned guests at state dinners ante-Norton. He says

now, with a certain wistfulness, "There was a time when our dining-room table was usable." He is referring to high-rise piles of exhibition catalogues, books, magazines, and papers that at least include alleys of visible tabletop between semi-organized zones. "Physics Today" is represented. Today is four years old. There's a suggestive copy of Allan Kulikoff's "Tobacco and Slaves" (University of North Carolina, 1986). The dining room, Dodge says, is his "assembly point" for the several hundred stacks of material that are elsewhere in the house, and which, as they are "processed," are moved by Dodge from way station to way station on their long yellowing journey toward cryptic preservation. From a geologic perspective, the dining-room table is active. I have not found much of anything on it more than six years old.

Ambivalent as it may seem, the guided-tour groups of Maryland House and Gardens Pilgrimage have visited Dodge's Cremona. The central hall, three stories high, which runs from portico to portico—pasture to river—under the floating bridges and airy balustrades of a nearly abstract set of stairways, is surely worth the ticket no matter what may be piled to the sides. And then a doorway frames an unexpected neat and tidy parlor scene in a pool of clear light: a style "O" 1902 Steinway grand piano under a tall English mirror from the eighteenth century, a Hepplewhite table, English music stands, an eighteenth-century English secretary, Audubon prints above the fireplaces. I feel compelled to

say that what I see in this suddenly kempt and becalming picture is the space of Nancy Dodge. It is one of a number of spaces like it elsewhere in the house. Upstairs, on the two sides of the great central staircase, are high-ceilinged bedrooms with fireplaces. One is ready for the American Wing of the Metropolitan Museum and the other is ready for an oceangoing barge—things in it everywhere stacked to waist- and shoulder-height, and books fifteen deep and cardboard boxes and shoes and copies of *Art News* and ties and bowls and sleigh beds. More than a few of the books are encyclopedias of art.

Nancy, trim as a trapeze, refreshing in voice and manner, could be mistaken for a flight attendant but actually is the dean of the Washington chapter of the American Guild of Organists. Her weekdays are very busy as she tries to solve the problems of those who play in churches, and on many Sundays she plays as well, freelance through the region, lured in each instance by the quality of the instrument. The music barn at Cremona contains a Rodgers organ. Nancy first happened into Cremona in 1975 to pick grapes. She knew a friend of the vintner Deshler. She worked for the Encyclopaedia Britannica Educational Corporation, which had sent her from Chicago to Washington to sell films to the federal government. At Cremona as in Washington, she is at the keyboard hours a day.

Dodge acknowledges that the parlor reflects Nancy's world, and in a tone of faint shame points out that

he is gradually penetrating it, his sign creeping relent-
lessly toward the grand piano from the southeast corner
and also from the far end of the room, where a samovar
stands on a small table near a Broadwood pianoforte,
and a Socialist Realist painting leans against a sofa. By
having some Socialist Realist official art mixed into his
underground collection, he establishes a kind of con-
trol group. In this example, two militiamen are being
honored for thirty years of service. They are without
expression and their skins are blue-gray. "Those faces
look dead," Dodge observes. "The artist maybe had
some slightly ulterior motive." A couple of Warhol Maos,
each a metre square, stand in a fireplace. In the offend-
ing corner are several dozen shopping bags (some full,
some empty), the molded interior of a carton that once
held thirty-six eggs, a complete newspaper nine years
old, maybe a hundred other items having to do with
art and exhibitions, and a pillow embroidered in homage
to Dodge: "God made only so many perfect heads. The
rest he covered with hair."

Asked for a state-of-the-pile report on this partic-
ular midden, Dodge says, "It hasn't been processed yet.
That's high among my priorities, as it has been for the
last ten years."

Beyond the parlor is a small impacted space that
may once have been a den but now is an outcrop of
stacked periodicals and a collection of recorded music
about as large as his collection of Soviet art; and beyond
that is a former kitchen, dating from 1819, with a stand-

up walk-in fireplace, a spinning wheel, a cutlass, a Navajo rug in the form of an American flag, hanging dried herbs and hanging dried corn and a hand of tobacco, and stockpiles of what Dodge describes as "art material in transition toward a permanent home; it's being assembled here." It's all Russian.

Of her "collector in all respects," Nancy Dodge has said, "He doesn't function in any disciplined way that I've ever been able to determine. Norton takes in information like a whale taking in krill," but he could serve as a case study in "competency linked with absent-mindedness—Norton *is* distractable." She has also said that he is accident-prone. And we are back to her question: "How could you ever get around the Soviet Union if you can't beat your way out of the St. Louis airport?"

He has rolled over in a convertible Porsche on Mallorca. As a delayed result of a pedestrian accident in New York City, his right eye is blind. Sitting beside him as he drives, Nancy will say, "Norton, I hope you have the other eye open." Describing a typical crisis on the road, she says, "There's a great honking, and he just floats through. The cars around him just part. He drives everywhere. He weaves around. Police stop him. He has an accident every other year." At stoplights, he tears clippings out of the newspapers he has been reading while driving. "Norton is critical of other people on the highway."

Not a few interior doors at Cremona normally

stand open, forming unintentional closets with adjacent walls. Behind the doors are tons of Russian detritus, countless mailing tubes, maps, posters, a baby violin. Nancy once told me that from the beginning of their life together Norton kept rifles and shotguns in the house behind doors. He assured her repeatedly that the guns were not loaded. Came a day when, just outside the house, a dog treed a groundhog. The groundhog went up the tree like a cat, fifteen feet, and froze there. Norton went into the house, saying, as he left, that he was going for a gun. While the dog kept the groundhog in place, Nancy held her breath. Silence extended itself. The dog's nose remained high. The groundhog tried to be its own shadow. From inside the house came the sound of a great explosion. Nancy imagined Norton dead. Norton, in his confidence, had pulled a trigger just for checking purposes, and had shot a hole in the dining-room floor. The renewed silence seemed endless to Nancy. Then a door stirred. He emerged from the house and shot a hole in the groundhog.

Leonid Borisov, *Art*, 1978. Paint, wood, nuts, and bolts on hardwood. 16⅛ × 23⅜ in.

Ilya Kabakov, from the album *They Are Flying*, no date. Ink and watercolor on paper. 7⅞ × 10½ in.

Victor Pivovarov, *How to Depict the Life of a Soul?*, 1975. Gouache and ink on paper.
16 × 11 in.

Ask Dodge a question and—as he free-associates —you get seventeen answers, sixteen of them to questions you had not thought to ask. It would be somewhat easier to interview the chips in a computer. Early in my visits to Cremona Farm, therefore, we began retreating at my request to a small room over the kitchen, turning on a microcassette recorder, and settling into a relationship in which he went into chain reactions in response to widely separated questions, and my professional contribution much of the time was little more than to fuss at him ("Speak up, Norton! Please! Speak up!"), because his voice was so low, filtering through the mustache, that I had to take the first cassettes to a lab and have them amplified by technicians.

When the topic drifted, as it sometimes did, in the direction of the C.I.A., I sat up more attentively, and we engaged in conventional dialogue. I could hardly

avoid wondering who had paid for the nine thousand works of dissident art and if it was just possible that in some small way I had. Dodge's friend Jack Cumberland, an environmental economist in Dodge's time at the University of Maryland, had said to me that working for the C.I.A. would have been "foreign to Norton's interests and values." Jerrold Schecter, who was *Time*'s bureau chief in Moscow in the late sixties, agreed, saying: "My impression is that he was an original." A source closer to Langley, Virginia, told me that Dodge had been strongly recruited to inform for the agency and had responded with a flat no.

Dodge repeated that in his general field just being associated with Harvard would brand anyone a spook. The Russian Regional Studies Program. The Russian Research Center. The Harvard Interview Project. "Who financed that? It was supposed to be the Air Force. Its headquarters were in the back part of the Library of Congress. But if you really looked deeper at it the money was coming through C.I.A. budget, going to the Air Force, then to Harvard from this thing in the back of the Library of Congress, which was the cover. So, you know, if anybody looked at things that I got involved with . . . You know, back in my day it was an honorable profession to be consulting for the C.I.A. My professors at Harvard had their file cabinets with locks . . . So therefore it made me a little more concerned that if they [the Soviets] ever wanted to set me up, make a case that they had done their research thoroughly, I would be vulnerable."

"When people went to Russia and came back, the C.I.A. asked them to be debriefed. Did they debrief you?"

"Not on these trips when I was involved with the art. I knew enough C.I.A. people through local Slavic groups, so, just in conversation, they could learn anything I ever knew."

"I learned that the agency approached you to represent them. Is that right?"

"I guess a couple of times people wanted to see me. I tried to avoid getting involved. When we came back from Russia in 1955, we stopped in England. Someone suggested that we meet some people who were supposed to know something about the science world. My father thought, Ah, we'll learn something. But it became evident that we were being interviewed by them instead of us interviewing them. They were obviously the MI-5."

"In the U.S., did this happen to you in the sixties and seventies, when you came back?"

"Not really."

"What about your being asked to represent the C.I.A. over there?"

"I never was asked to 'represent' the C.I.A."

"Well, you know—report to them."

"Well, there's some guy that wanted me to meet him down in front of some theatre in D.C. but I didn't want to get any connections. I can't remember whether it was the F.B.I. or the C.I.A."

"He wanted to meet you in front of a theatre?"

"Yeah, one of the main theatres. I can't remember now. Did I meet him, and then I told him I wouldn't tell him anything and he vanished? I don't think I even . . . I really can't remember now, because there was really no meaningful contact."

"You didn't tell them that you didn't want to have anything to do with them?"

"Some of my best friends were in the C.I.A. I was professionally involved—not doing work for the C.I.A., but, you know, putting on conferences. And they were giving papers, and I was editing papers, and it was a way they had a window out to the outer world. A lot of these people were frustrated academics, and they participated in our annual A.A.A.S.S. conference, or came to our three or four meetings a year, and presented papers, and when they came to the national thing they would have some of their desire to have their work known satisfied."

"You knew so many C.I.A. people that you were talking to them in an informal manner anyway, is what you're saying, right?"

"Yeah. I was writing papers and doing a book."

"When you came back from your travels did they talk to you about what you learned?"

"Not specifically."

"But you were in touch with them."

"Yeah. In the normal course of events."

"Given all that, is it fair to say that the C.I.A. knew what you were doing and was in dialogue with you?"

"I wouldn't say so. I was not aware of any particular involvement. It's just that these people would know what I was doing."

"Did they ask you to report to them and you refused them?"

"Nobody had any reason to ask me. They knew anything I was doing anyway, because they were my professional colleagues."

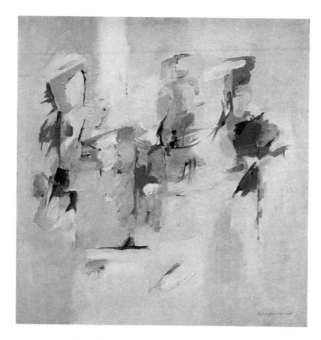

Viken Tadevossian, *Trio*, 1975. Oil on canvas.
28¼ × 28¼ in.

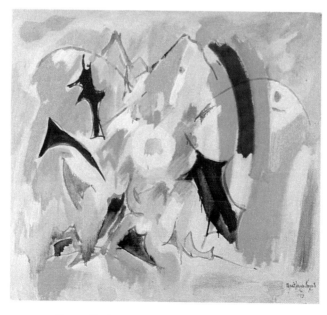

Seyran Khatlamadjian, *Rainbow*, 1973. Oil on canvas.
31¾ × 35¾ in.

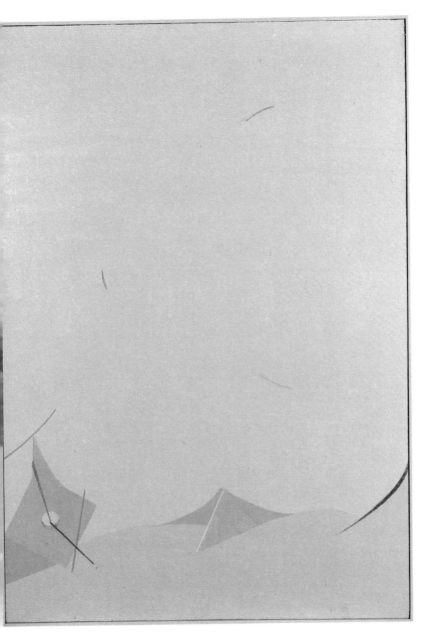

Eduard Shteinberg, *Composition, March 1979*, 1979. Oil on canvas. 47¼ × 33½ in.

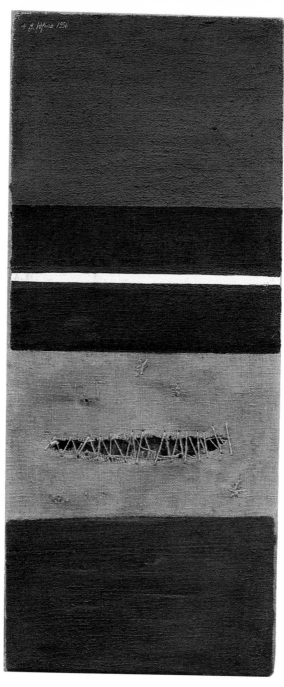

Valery Yurlov, *Construction—Counter-Form*, 1956. Oil on bur-
lap. 61½ × 26½ in.

The conversation also touched from time to time on how Dodge got the artworks out of the Soviet Union. The topic cannot be said to have drifted in that direction, because—even now, in post-glasnost time—it was a vector he preferred to avoid.

"The question would be on anybody's mind," I said to him one day. "What can you tell me to help me out?"

He said, "If you want to imply that I carried stuff out wrapped up in political posters, that's true."

I reminded him that he had already mentioned that.

He said, "You could finesse it by saying, 'Because it may compromise certain people who were helpful, Professor Dodge cannot . . .' "

I said I couldn't imagine whom that would finesse.

He said, "I'm not interested in telling the story of how it came out. That's what it boils down to."

In another conversation, after meandering by free association into a period in the mid-seventies, he said, "I managed to find more help in getting artworks out. And I thought, This is sort of a window of opportunity, so I should pick up the pace."

I asked, "What was the window of opportunity?"

"Well, some help. Getting it out."

"Who gave you the help?"

"That's where we don't want to be very specific, but more help from people stationed in Moscow—help in a more significant way."

"How did the things travel?"

"That's what we can't be very specific about."

"In household goods?"

"That's one way."

His size limitations when he was smuggling on his own began with the dimensions of his suitcase and escalated into his utility bag and his dark-blue nylon drawstring sack, out of which a rolled painting two feet long would not protrude. But that was his upper limit. In his words, "If something was three feet wide and four feet long, one might worry that someone might think you were walking out with the plans for an atomic base . . . If I had help from somebody that had better ways of getting things out than I, why then I could carry bigger things. Yankilevsky did big works that were particularly difficult to get out. I bought small works of Kropivnitsky but couldn't handle the big ones myself."

The unofficial artists had no idea where their paintings went, but of course they had their theories:

"He was getting works out maybe through high places in K.G.B."

"We say of American paintings that they are sofa-size. In Russia we had at that time suitcase-size. There was a favorite joke of all of us: the work had to fit in a foreign suitcase."

"Our works were smuggled, but we never smuggled the work. We talked like this: 'Who took your work?' 'John.' 'Where is John?' 'I don't know; he went abroad.' 'Who is John?' 'I don't know.' "

Dodge said at Cremona, "Much of the collecting I can talk about. But it's the people, that early phase, where I don't want to finger anybody as exceeding their authorized activity."

"The extent to which you can tell the story is the extent to which I have a story to tell."

"What you're asking me is what I try to keep everybody interviewing me about the subject away from. I want people to be interested in the art, not, quote, the smuggling. Because that might finger people I don't want fingered. They are counting on me never to get them in trouble. Even if they are retired, I am worried about it. I was getting what the government called worthless stuff out. This art—considered to be useless —could be seized. A Russian was not supposed to sell anything for dollars. While I may have been violating

a lot of their laws, I wasn't violating any laws here. But I don't want people who may have done things that were not according to their job restrictions getting into trouble. While people may be retired or out of reach of any retribution I don't want them to be embarrassed."

"Well, all we said was 'People stationed in Moscow . . .' "

"That I think you can carefully say."

On another day, in his generosity, he came up to the room over the kitchen with a prepared, and slightly more helpful, statement, which he prefaced by saying, "I don't know if I can discover any nice little vignettes that don't affect—even indirectly—anybody that I was involved with, but I think you can probably get out of this enough to give people with their imaginations some notion of how it was done. Lord knows, I don't know myself how some of these things got out." He read from a piece of paper: "Although the American embassy was very strict, other embassies in Moscow had very little control over what their personnel exported—particularly the South American embassies, and some European." He went on to say, in amplification, "Latin American diplomats became substantial collectors. A number of South American ambassadors became interested in unofficial artworks and became major collectors and brought them out, as did European embassy personnel. These people were able to bring art out with their furniture when they left. Maybe that gives you

another little hint as to how one might get things out." If he was veiling some people at the expense of others, he was also confirming that most of the smuggled stuff was smuggled out in the household goods of embassy people, whatever flag they might wave.

Others are more candid. "A lot of art was pouched through my husband's contacts," Elena Kornetchuk says plainly. During the Nixon and Ford years, her husband, Jon Showe, was Special Assistant to the United States Trade Representative. His portfolio included Eastern Europe as well as transportation.

Dodge did some fretting one day that in mentioning the role of C.I.A. people he had been "letting a cat out of a bag," but then he went on to deliver another cat: "In terms of who could take things out, the C.I.A. had a world of its own. They knew how to do it. The State Department had tighter controls over their people than they would over the C.I.A. people that were assigned to the embassy. You didn't know who they were, just as in the Russian embassy we didn't know who the K.G.B. people were. But you might have a good idea, just from meeting these people."

"If you were guessing how many C.I.A. people were collecting art, what would you guess?"

"Very few."

"A dozen?"

"Fewer than that."

"How would a C.I.A. person get something out in

a way that was even more adroit than what a State Department person would do?"

"Perhaps in the same way, but they wouldn't be subject to the same rules—the same internal control."

One former C.I.A. agent has fifteen Rukhins.

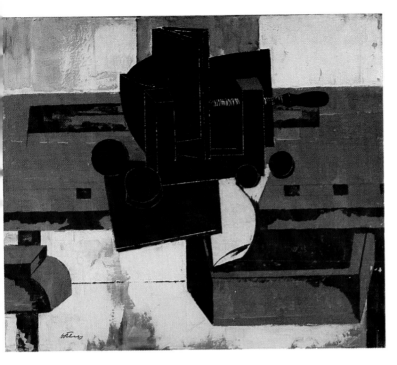

Ojars Abols, *Joiner's Clamp*, 1966. Oil on canvas. 34 × 40¼ in.

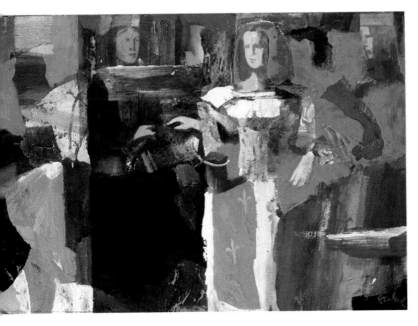

Dzemma Skulme, *Dialogue*, no date. Oil on canvas. 43 × 62¾ in.

Evgeny Mikhnov-Voitenko, *Composition*, 1974. Gouache on paper. 16⅜ × 11⅝ in.

For eight works of art, Dodge paid Evgeny Mikhnov-Voitenko a thousand rubles, in 1975, at a dollar sixty a ruble. That was a representative purchase. On the average, he paid Rukhin three hundred and fifty rubles per canvas. For some individual pieces, he might pay certain artists as much as five hundred rubles, but not often. He told the artists that he wanted to pay them the going rate. Often—particularly in the sixties—there was no going rate. The artist had never sold anything before. Of that thousand-ruble deal with Mikhnov-Voitenko, Dodge says, "I was trying to negotiate something that wouldn't wipe me out and would keep him going for some months." Dodge's interest in keeping the artists going outpointed his interest in any specific work. Speaking for all, one artist has said of Dodge in those early years: "He singlehandedly created an economic base for unofficial art."

There was no limit on the amount of money that could be brought into the Soviet Union. Dodge cashed traveller's checks in his hotel and, in his words, "never changed a nickel illegally." He was running enough risk without adding the black market to a list he might hear in Lubyanka. Had he dealt with illegal moneychangers, the K.G.B. would have come to know of it.

He was not above haggling. He was prepared to pay "the going price, but not necessarily the going price to an embassy person." When Dodge goes out of Cremona Farm to buy a peck of oysters, he fixes his eye on the oysterman and bids less than is asked. Dodge is thrifty to the point of valor. If Scotland had a Congress, he could win its Medal of Honor. He has worried about people taking too many figs from his ficus. Deshler the vintner says of him that he is "close with money to the point of being amusing, which is not discordant with collecting." The Tupitsyns, when they met him, quickly read him as a comprehensive collector who spent nothing on himself:

"He tries to cover everything. He wants to create a full picture of what happened."

"His clothing is fifty years old."

Travelling around cashing checks, he seems not to have spent much more than a hundred thousand dollars in the Soviet Union on the art he selected in studios and apartments. But over the years, as he developed ways of getting things sent to him, he increased his outlay to "several millions of dollars."

I could not help letting it cross my mind once more that it was within the realm of possibility that "Harvard" or the "Library of Congress"—or some such—might have had a part in these transactions. Irking him anew, I asked him where the money had come from. He had told me that he had sold stock to pay for the art. But where had the stocks come from?

He said he would "rather not get into the sordid side of money."

I said that I was in complete agreement that talking about money was ignoble and vulgar, but in this instance we were talking about an art collection drawn from the Soviet Union in the sixties and seventies and thereafter, and that the source of the money that paid for it was too pertinent to be ignored.

He said, "If you want to be specific about it, you could say that the collection has been evaluated at fifteen million dollars."

That was interesting but not what we were discussing. The question before us was not what the value had become but where had a college professor obtained the "several millions of dollars" that had built the collection?

"Assets," he said. "Liquidating assets."

"You liquidated your TIAA-CREF?"

Laughter.

"Not everyone with an idea like yours could carry it out. Are you the scion of a very wealthy family, or did you make this money on your own? How could a professor do it?"

"Astute investment. You could say, 'Unlike some economists, Norton Dodge was an astute investor.' Or something to that effect. I hate to be too open about some of these things."

"Astute investment is not going to turn an instructor in the Ball State English Department into J. P. Morgan."

"No. You just have to know a J. P. Morgan."

"Yes, but the instructor wouldn't have enough money in the first place for it to turn into so much. It's not like the loaves and the fishes. There had to be a sufficient something in order to have it grow like that. If you invested ten thousand dollars, it wouldn't turn into four million dollars."

"If you invest ten thousand dollars and it doubles every four years, in forty years you have ten doublings. So, we have ten, twenty, forty . . ." He was roughing it out on paper. ". . . eighty, a hundred and sixty, three twenty, six forty, one million two hundred and eighty, two million five hundred and sixty, five million one hundred and twenty, ten million two hundred and forty."

"That's how many years?"

"Forty years."

"We're not talking about forty years."

"I became an investor at a very early age. I'd rather you not get into any vast detail here."

"Did anyone help you pay for the paintings?"

"No."

"You paid for them all by yourself."

"Yeah. In '62, I probably spent just a few hundred

dollars. In '65, it was maybe a few thousand. In the seventies, it began to pick up. So there were many years for things to accumulate."

"How many people in the academic world do you know who have bought three million dollars' worth of art from anywhere and also have a nine-hundred-and-sixty-acre farm?"

"If they bought the farm very cheap and if they bought the stock very cheap, they could have it. There are now professors that are raking in vast sums if they write a major textbook."

"You didn't write a major textbook. I'm just looking for a compact, satisfactory answer to the question. It would be very easy if I could say, 'He and his father made Dodge motorcars,' but you didn't happen to."

"You could say, 'Norton Dodge's father, a physicist, and Norton himself, an economist, sought out the most capable investment analyst and were able to identify ahead of many other people Benjamin Graham and Warren Buffett,' and just leave it at that. That's all you need to mention."

"Oh."

"Benjamin Graham. Warren Buffett."

"You can understand the point of interest in this."

"Unfortunately."

John C. Bogle, the chairman of the Vanguard Group of Investment Companies, repeatedly mentions both Graham and Buffett in his benchmark "Bogle on Mutual Funds," published in 1994. Bogle refers to

Graham, who was an adjunct professor at Columbia University and author of "The Intelligent Investor" (1949), as "one of the most successful investors of his time" and to Graham's mentee Warren Buffett as "probably the nation's most successful investor." Almost nobody is worth more than Buffett. He has accumulated about nine billion dollars. The common stock of Buffett's company, Berkshire Hathaway, has been traded on the New York Stock Exchange for almost twenty thousand dollars a share. A round lot of Berkshire Hathaway would have made a significant impression on the Soviet underground art world in the time of Leonid Brezhnev.

"Thanks to Warren Buffett," Dodge continued. "You could say, 'Thanks to Warren Buffett and other followers of Ben Graham.' With Professor David L. Dodd, Ben Graham wrote the book 'Security Analysis' [1934]. Graham & Dodd, as it was called, became the bible of the analytical security analysts. They dug deep and looked for intrinsic value in securities. They revealed the true worth of a company. Graham was always looking for the special situation where the market's view of something was quite disconnected from the actual worth of something. My father encountered Graham in 1940."

In 1940, Norton Dodge was thirteen. His ambition, until then, had been to be an artist. Age eleven, twelve, he had hung around sculpture classes at the University of Oklahoma, sketching live females in swimsuits. In the basement at home, he did a mural of cowboys

rounding up horses. His father, Homer Dodge, was descended, like nearly all American Dodges, from two brothers who arrived in Salem in 1635. The Phelps Dodges and the internal-combustion Dodges are of this tree but not, alas, of his branch, Norton said, exhaling. On his branch were farmers and educators from Vermont and upstate New York who were eternally thrifty and had reason to be. His mother was Margaret Wing, of Columbus, Ohio. Her maternal grandfather was Norton Townshend, a trustee of Oberlin College, a founding trustee of Ohio State University, a one-term abolitionist congressman, and a descendant not only of Turnip Townshend, the scientific farmer, but also of Charles Townshend, the eighteenth-century Chancellor of the Exchequer who helped to cause the American Revolution by repressing the colonies with the tariffs of the Townshend Acts. Her father was the president of a bank in Columbus and also a trustee of Ohio State. By 1940, Norton's mother had come into "a nest egg," and the question of what to do with it had led to Benjamin Graham. This caused young Norton, by his own account, to forsake his artistic ambitions and become interested in economics. Aged thirteen, he began playing the stock market in his head.

Alexander Kharitonov, *Landscape with Shrine*, 1972. Oil on fiberboard. 10¼ × 14⅜ in.

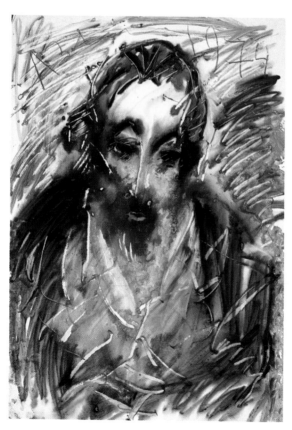

Anatoly Zverev, *Portrait of Victor Tupitsyn at Age 31*, 1974. Watercolor on paper. 33½ × 24 in.

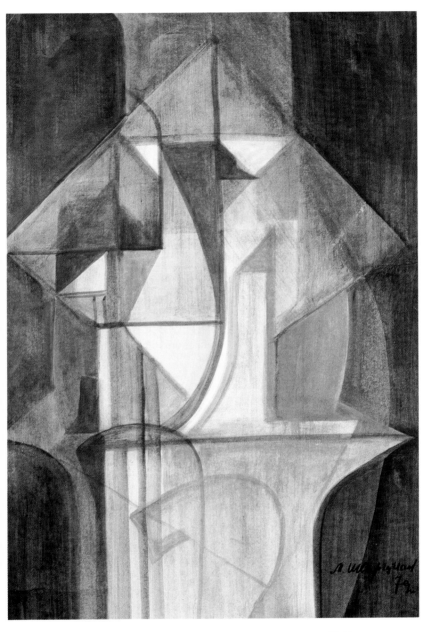

Mikhail Shvartsman, untitled, 1972. Gouache on paper. 34½ × 25½ in.

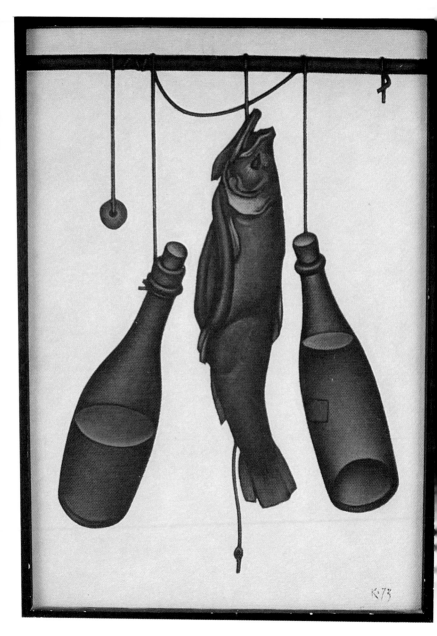

Dmitry Krasnopevtsev, untitled, 1973. Oil on fiberboard. 25½ × 18 in.

The Rukhin exhibitions that took place in 1975 at the North Carolina Museum of Art and the Phillips gallery in Washington were gathered principally by Sarah Burke, the Slavic-languages professor from San Antonio. Dodge had known her for some years, and she had been the first to make him aware not only of Rukhin's existence but also of his preeminence among Leningrad artists. She gave him Rukhin's address and telephone number. In years that followed, she helped with some of the logistics of amplifying Dodge's inventory of Rukhins and identified people who were useful in the matter of transportation. Rukhin, for his part, looked to Sarah Burke for a great deal more than the sale of a few tens of his paintings to Dodge. He looked to her to help him get hundreds of his paintings out of Russia and declared to her his intent

to follow. He was in love with her, she forthrightly avows.

For a consortium of American colleges, Burke taught in a Russian-language program at Leningrad State University in the summers of 1973, 1974, and 1975. She knew Rukhin almost from the beginning. She went to his studio to buy a painting. He offered her Capital City (Stolichnaya). They talked. He offered her more Capital City. She passed out. She was thirty-two. She bought one of his paintings in which a seal had been pressed into thick white gesso. In collage fashion, an icon cover was in the center of the painting. The upper two-thirds of the canvas was inviting and white. The lower third was brown and black and seemed an abstraction of incendiary destruction. A real hinge, set into the gesso, connected the bright and the dark spaces. In San Antonio, the painting hangs above the dining table in the home of Sarah Burke and her husband, a technical translator. Rukhin liked hinges. He went through a hinge period. That C.I.A. person's fifteen Rukhins all incorporate locks and hinges. In Moscow once, Rukhin took Sarah Burke to a lock-and-hinge museum.

Among the Rukhins that hang in her house in Texas is one that features her birth date stencilled near the words "Dangerous for Life." In her bedroom, against a background without representational meaning, a series of seals from travelling icons form a great cross. There is a picture elsewhere of a broken crate

before a white background. But spiritual reference and connoted symbolism are much less in evidence than Rukhin's essential abstraction, the enigma of the found objects in the thick gesso.

He took her around Leningrad in his old Volga. She says that by the end of that first summer she was prepared to give herself to his art, to do whatever she could to advance it. Rukhin said he dreamed of buying a clipper ship, filling it with his art, and sailing down the Gulf of Finland, west over the Baltic Sea. At Christmas, he cabled her: HAPPY NEW YEAR, LOW REGARDS, NEVER GOODBYE, JENJA.

Galina Popova, widow of Rukhin, says of Sarah Burke, "She was in love with him. I almost killed her once."

Galina recalls Rukhin's explaining to her about Burke, "She is transportation for my paintings. She comes and goes like a plane."

"She lived in my bed with my husband," Galina continues. "I found cigarette butts under the bed."

According to Galina, a cousin of Rukhin was visiting one time, met Burke, and said to her, "You are just one of many." When Burke asked her "Who, for example?" the cousin said "Me, for example."

Remembering the milieu of Rukhin's studio, his friend the poet Kuzminsky has said, "There were never orgies. Galia never paid unexpected visits. We drank together. Sometimes the girls stayed there. Why not? It's normal."

"In Russia, everything is left indefinite," Burke says. "Innuendo is what remains. Everyone who has lived in Russia says that they have lived a Dostoevsky novel. I know I did."

The plot ascended to a structural apogee on an evening in Lenin Park. It was the end of the summer of 1975, and Jenja said goodbye to Sarah, said goodbye again, lingered, kissed her once more, and ultimately walked out of the park and took a tram. Galina had shadowed the couple and observed the scene. Now she rushed at Sarah with a knife, and, as Sarah remembers it, went after her hair. Sarah dropped her handbag, grabbed the knife by the blade, and struggled, slicing her fingers. Bloody, she fled. In the handbag was her money and her passport and her papers. Galina picked it up, walked a short distance into the Leningrad zoo, and heaved Sarah's handbag into the lions' den.

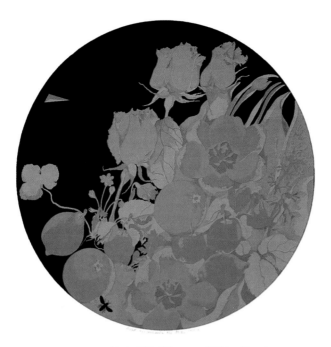

Malle Leis, untitled, 1975. Silkscreen. 19¼ in. diameter

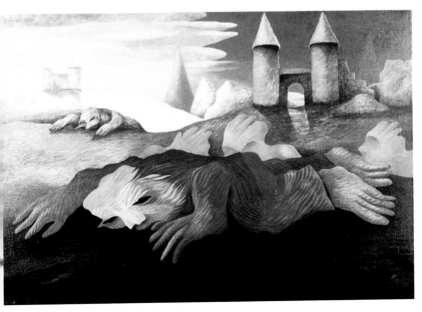

Juri Arrak, *Keskaegne Legend*, 1980. Oil on canvas. 38⅜ × 57¼ in.

Raul Meel, No. 10 in the series *This Beautiful Land Is My Home*, 1980. Silkscreen and ink. 16½ × 16 in.

Andres Tolts, untitled, 1983. Oil on canvas. 50¼ × 58⅜ in.

In 1976, Norton Dodge signed up for a Smithsonian tour—Moscow–Leningrad–Tallinn–Moscow—and Elena Kornetchuk signed up, too. She was twenty-five —a Ph.D. candidate in the Russian-studies program at Georgetown University preparing a dissertation on the politics of Soviet art. Through Dodge, she had become interested in the unofficial artists, and in Russia she joined the Smithsonian group for occasional meals, but spent even less time on the tour buses than Dodge did. Bearing toothbrushes and cosmetics as gifts, she tracked official art by day and unofficial art with Dodge at night.

Heaven knows what the K.G.B. made of her. Her great-uncle had been Minister of Communications in the Kremlin under Stalin. Colonel Kornetchuk, her father, a hero of the Great Patriotic War, defected in 1949, the year before she was born. He and her mother worked in the news section of Radio Liberty, in Munich, where

Elena went to an American school and then to a German branch of the University of Maryland. Talking with her, one would never guess that she grew up and went to high school anywhere east of Allegheny County, Pennsylvania, where she lives and has her gallery now. Blond, vigorous, mint attractive, she seems more to have been a mid-American cheerleader than a European whose first languages were Russian and German. She transferred to College Park when she was eighteen, and was soon enrolled with thirty-nine other students in Dodge's course on Soviet economics—"I had very long hair, fell asleep in his classes, and got the highest grades." She remembers the piled chaos in Professor Dodge's office. She remembers "his heavy-duty economic charts." She remembers that as a result of his lecturing style he was known to his students as Snortin' Norton. Kornetchuk recounts a memorable lecture in which, chalk in hand, Dodge began at the left end of a series of mural-sized blackboards and gradually filled an acre of slate with numbers and symbols and signs and ciphers until he was three-quarters of the way across the room, whereupon he realized that he had made a basic, primal, irrecoverable mistake, and, snortin', erased it all.

Dodge paid Kornetchuk to read and summarize Russian articles, abetting his research on various projects, including one called "Incentive Systems in the Soviet Union." He also hired her, in her grad-school years, to track down people in the United States and Canada who had bought unofficial art while stationed

in the Soviet Union. In 1974, she went to Russia with her future husband on one of his official trips. From her work with Dodge, she had names and addresses of unofficial artists. The naval attaché in the United States Embassy was a friend of hers from Georgetown. In an embassy car, he would drive her around Moscow and let her off several blocks from her destination. Dissidents preferred not to have United States government vehicles hovering in front of their doors.

Eventually, she would arrange with the Soviet regime to be the exclusive American importer of Soviet art. Into her shipments, friendly apparatchiks in the Ministry of Culture would slip the work of underground artists. She was to become an important broker to the Norton Dodge collection. After three or four years, the K.G.B. would cut this off. They would try to recruit her as an informer, offering her unlimited unofficial art in return, and when she refused they would take away her visa, saying, "See if you ever get back into the country."

All that was ahead of her in 1976, on the journey she made with Dodge to Russia—"a moveable feast in art," as she describes it, racing after taxis, visiting three or four apartments in a night and sometimes as many as eight, partying with the artists and going off to dance. Dodge may have been twice her age but he was her equal in stamina. "Norton was always good for all-nighters," she continues. "You don't sleep over there. You sleep on the plane flying home." With Oskar Rabin one night at 2 a.m. in Moscow, they could not get a

taxi. A Red Army truck came along, and the artist stepped into the street and halted it. He spoke to the soldiers, and paid them rubles, and the Red Army truck became a taxi. In Leningrad, it was always necessary to get home before the drawbridges went up for the night. Rukhin would stop official army cars with officers in them and pay the officers.

"If Norton thought an artist needed support, he bought stuff even if he did not want it," Kornetchuk says. But there seemed to be little he did not want. "If it was sexual, he liked it," she goes on. Trying to corner everything, he became irritated with her if she attempted to buy a painting for herself. "He bought indiscriminately. All big collectors buy indiscriminately. He also has a penchant for real kitsch. Have you seen the Christs in the bathroom at Cremona?"

In an overnight train from Leningrad to Tallinn, Dodge and Kornetchuk were in a standard four-bunk compartment with a couple of kolkhozniki in the other bunks. These were kolkhoz farmers, small farmers, and they emanated essence of silage, essence of fodder, essence of pig. Dodge found the smell intolerable. He aerosoled the compartment with a can of spray deodorant. The farmers were openmouthed. One said to the other, "Americans are so sophisticated they can iron their suits with spray."

Asked to comment on the risk involved in Dodge's travels, Kornetchuk says, "It was courageous for the artists to meet him, and it was courageous for him to

meet the artists." If she and Dodge were followed in Moscow and Leningrad, they were unaware of it, but there was no doubt in Tallinn. Rukhin joined them there to help Dodge meet new people. Dodge picks up the story: "A group of us, including Tonis Vint and other Estonian artists, went around with Rukhin. Six feet plus, with his great big beard and long hair, he stood out. As we travelled around, we picked up an entourage of secret police, who followed us in two cars as we went from one artist's apartment to another. I remember looking out from the balcony of Malle Leis's apartment. We could see figures pulling back into the shadows of buildings across the courtyard. As we were leaving, we could see somebody whisk around a corner. We later saw the lights of a car following us."

They arrived at Vint's apartment with much of the Estonian avant-garde. Siim-Tanel Annus was there. Juri Arrak. Leonhard Lapin. Andres Tolts. Peeter Ulas. As the group arrived, excited, everybody ran to the living room and sat on Vint's black-and-white furniture among his black-and-white paintings on the walls, turned on the black-and-white television and watched "Kojak" in Finnish. Looking down from Vint's and any other apartment, the amused Estonian artists pointed out the K.G.B. cars, the figures pulling back into the doorways, the people standing in shadow. Not long ago, at Cremona, I said to Dodge, "I've heard so many K.G.B. stories that I'm beginning to form an opinion that they weren't always exceptionally smart."

[*145*]

He said, "That's very true. That night in Tallinn—checking up on this strange-looking bunch, following along in their van—I don't think they knew very much what was going on. But a thing that often bothered me was that if I would see an artist maybe the K.G.B. would then follow up by pressing them and in effect harassing them afterwards, you know. It just happens that Rukhin did get into trouble."

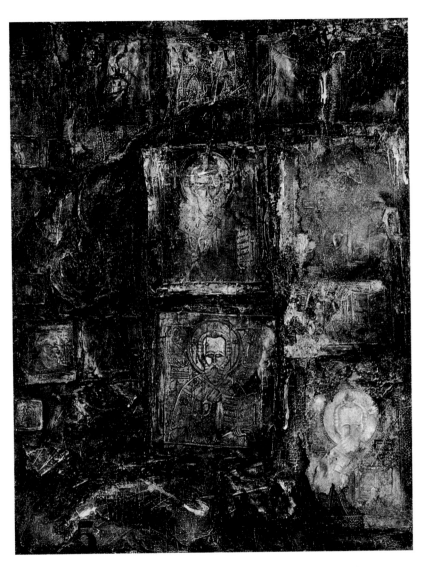

Evgeny Rukhin, untitled, no date. Mixed media on burlap. 36¼ × 29⅛ in.

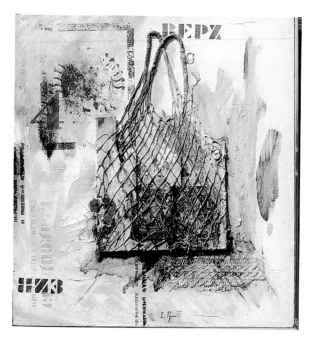

Evgeny Rukhin, untitled, 1975. Oil, synthetic polymer, and assemblage on canvas. 25¾ × 27½ in.

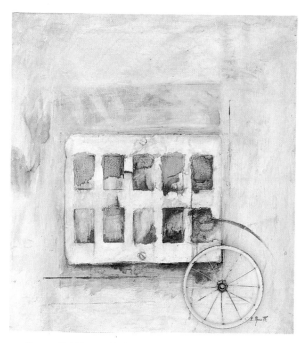

Evgeny Rukhin, untitled, 1975. Oil, synthetic polymer, and assemblage on canvas. 39 × 37 in.

Rukhin was burned to death the following weekend. Thirty-two years old. He went home to Leningrad from Tallinn, went on to Moscow to spend two more days with Dodge and Kornetchuk, then returned to Leningrad, where he died while they were in the air flying to New York. Galina, his widow, believes he sensed that death was coming: "The circle was closing around him and he felt it—closing very rapidly. He told me, 'Death is following me and is behind my back. You must be prepared.'" While he was in Moscow, one of his geological colleagues from earlier times visited Galina, and she took him to the studio to see Rukhin's work. July heat was intense. After climbing the narrow steps to the studio and seeing the clutter of wood, rags, papers, and paints, the geologist said, "One little spark and it will go up in flames."

"Oh, don't say that," Galina said.

On the final night in Moscow, Rukhin and Elena Kornetchuk and Vladimir Ovchinnikov and others had dinner at the mansion of the Venezuelan ambassador, Régulo Burelli Rivas. In a large basement room, where spinning lights sprayed color as if on the walls of a nightclub, hung the work of Rukhin, Rabin, Ovchinnikov, Kabakov, Masterkova, Nemukhin, Pivovarov, Shteinberg—a major collection of dissident art. While several hundred examples of Rukhin's work would make their way to the United States, even more were destined for South America. He sold to Uruguayans. He sold to Colombians. The Italian-speaking Yugoslavian wife of the Argentine ambassador was a collector of Rukhins. A palace near Lima is copiously adorned with Rukhins. Ema de Zalamea, of the Colombian embassy staff, bought more than twenty from him. One day, she had appeared on the Neva in a Colombian ship with Burelli Rivas aboard. She took him to the studio and introduced him to Rukhin. Burelli Rivas was a poet-diplomat who knew large tracts of "Eugene Onegin" by heart and wove strands of Pushkin into his own poems. His embassy soon had a whole room of Rukhins. One day not long after Rukhin's death, the Soviet government gave Burelli Rivas twenty-four hours to leave the country, because he had met with dissidents. As he left, they impounded his luggage.

DODGE'S VERSION

As Norton Dodge imagines the details of Rukhin's death, he says of the K.G.B., "They perhaps expected him back the next day and therefore thought they would burn out his studio in his absence as an object lesson. There were four at the studio having a party with much drinking: Rukhin and Ilya Levin, a writer-poet, and Evgeny Esaulenko and Esaulenko's wife, both artists. Esaulenko's wife also died. The fire department held back. Because Rukhin was an organizer of other artists, burning his place was a warning to all. The K.G.B. probably didn't know he was there." Dodge also says that the death of Rukhin quickly became a story variously told, with about as many versions as there were tellers, and since it was also a story seemingly known to silent narrators its mystery had been pre-served. What was indisputable was that a fire had destroyed Rukhin's studio over the old stable in Len-ingrad and at the same time Rukhin and Ludmila Boblyak had died.

MELAMID'S VERSION

The Moscow artist Alexander Melamid presents the story this way: "There are two main versions. (1) K.G.B. (2) He lived dangerously. Dangerously? Going to the foreigners drinking. He kept a bohemian image. It sets you free from social bonds. He was the freest man of all of us. It seemed that he had no fear. We all knew that he would pay for this sooner or later. What watched

him, God or the K.G.B.? Either God or the K.G.B. punished him. Was it intended that he die? It doesn't matter. Crime and punishment."

BURKE'S VERSION

On that Saturday, Sarah Burke in San Antonio was expecting a call from Rukhin. They meant to plan things. She was soon to make a trip to Russia. "I waited and waited and waited. I couldn't believe he was dead until people sent me pictures of him dead." Burke outlines what she sees as three possible causes: "(1) The K.G.B. (2) An accident. (3) His wife." Elaborating each in turn, she continues: "The K.G.B. were following his movements pretty carefully. Some people think that Ilya Levin did it for them, that he was 'politically inspired.' It's a possibility. They were all getting hassled—all those from the bulldozer exhibit. Rukhin became a martyr. No one knows where the fire started. Buckets with oily rags in them were always on the stairs. Someone could have thrown a match in. Artists really ran scared after that. Most people believe that the fire was set, but I think it could have been an accident—the studio full of vodka, cigarettes, and the chemically soaked rags. Of the four, two ran. They didn't call the fire department. Esaulenko ran. His wife died. Zhenya died. There was a lot of smoke. They died from poisonous fumes. The other who ran was Ilya Levin. Some think that Galina did it, because Zhenya meant to leave and come to the United States."

[*152*]

KUZMINSKY'S VERSION

"It smells rats. It couldn't be an accident—simply. It's still a mystery. I made a careful investigation. The studio had very low ceilings. In the first room were carpets and beds. The second and third rooms were studios. On the other side of the stairs was the room with the skylight. It was for storage and was full of materials. Parties were always in the first room. The windows were blocked with wood because of neighbors. Rukhin arrived from Moscow, met Levin for dinner, and invited Esaulenko and Ludmila to join them. She was not officially Esaulenko's wife. She fed him—working as an artist. She was an official artist. She got her salary that day. She added liquor. They went to the restaurant, then bought the booze and went to the studio. Esaulenko preferred booze to sex. He was drinking and dozing. Rukhin was a woman chaser, but, you see, Ludmila was always horny. She wanted, too. With Ilya, they were making love sandwich-style in room 3. The fire started in the storage room—where nobody smoked. The front door was closed. Nobody could enter. Fire blocked the exit immediately."

Kuzminsky says also that he has no difficulty imagining the response of agents from the K.G.B. upon discovering two men closely compressed to either side of Ludmila. "Maybe Esaulenko opened the door. Maybe they used their own keys. When they came to the last room, seeing the lady intercoursing with two fellows, I know what those K.G.B. prudists would think. They

[*153*]

said something nasty. Ludmila attacked them. They hit her. Even if a lady strikes them they answer with a good professional blow. Rukhin defended her. They hit him. Then they set the fire. Galia says that when they put Rukhin in the ambulance he was alive. They finished him there. Levin and Esaulenko are selfish cowards. They never will protect nobody."

In the aftermath, there was an official assertion that Rukhin and Ludmila, if not the others, were users of drugs. This particularly offends Kuzminsky. "They found Rukhin's and Ludmila's bodies naked on the corridor floor. Not in the third room. Rukhin's skull was broken—a hole. Galia said she put her fingers in the hole. On Ludmila they found the holes of injections. I can testify on a Bible that none of them were drug addicts. Ludmila, she was pure alcoholic. She never took drugs. Nor did Rukhin. They were healthy alcoholics."

GALINA'S VERSION

Rukhin was in his apartment that Saturday at midday taking a bath. Galina looked in on him. "He was lying there covered with bubbles. He never had a headache. He never looked hung over. I asked him, 'Why are you destroying yourself?' He went to the studio at 3 p.m. At 10 p.m., he called and asked, 'Do you need help with the children?' I said, 'No, they're in bed.' He said, 'Don't worry. I will be working.'"

Through much of the evening, she was in the

kitchen listening to music. At midnight, she called the studio. There was no answer. She did laundry and some cleaning. Returning to the kitchen at 3 a.m., she called the studio again. She heard "a strange noise" in the phone. Her older daughter, Masha, suddenly appeared, saying that the younger one, Lisa, was crying and asking for her. After comforting Lisa, Galina fell asleep. She was awakened by a policeman, who said there was a fire in the studio.

"Where is Evgeny?"

"The Emergency took him."

She dialled Emergency, and asked, "Where is my husband?"

Emergency said, "At the morgue."

She called a friend who she later decided was connected with the K.G.B. The friend stayed with the children. There was a crowd in the courtyard below the studio. Neighbors told her that during the height of the fire two men appeared in the studio windows, one with a woman's purse. The two were afraid to jump. The neighbors brought a ladder, and the men came down. A fire engine arrived. Someone asked the neighbors for Galina's address. The man with the purse said, "Don't bother for twenty more minutes. Wait." "Why wait?" the neighbors said. "Just wait," said the man with the purse, and then he was gone. From the neighbors' description of him, Galina knew that they were talking about Esaulenko and that he had departed the scene with his wife's money. She called Esaulenko's

apartment. He answered, and she said, "What is going on? Ludmila—where is she?"

Esaulenko said, "She is where your husband is."

At the police station, a couple of blocks away, a policeman wrote a slip authorizing her to identify the body of Evgeny Rukhin in the morgue, and another slip authorizing her to identify the body of Ludmila Boblyak. Galina says that Ludmila was "a beautiful, talented woman" and that they were friends in art school. She continues, "They lifted me his body on elevator. He looked very calm. I had this feeling right away: he didn't die accidentally."

Galina went straight to the K.G.B., and said, "I saw him at the morgue. I know he was killed. I saw it in his face." The agents closed doors, and described to her a lewd, orgiastic scene. She said to them, "I know he was killed."

She went back to her home and children. Soon, the telephone rang. A court was calling. Why had she not been at the hearing? "The hearing?" she asked. "What hearing?" The hearing of the man who had tried to kill her with the knife. She said, "My husband died this morning."

Ten days later, she went to the rescheduled hearing of the man with the knife, and was told by a court secretary that on the day of the studio fire the man had not been in his cell. A guard said to Galina, "You do the blaming. Hah! He will be free in a couple of days and will come and finish you." The judge tried to be

helpful. "The judge told me, 'You have to get out of Russia or your children will go in the way that your husband did.' She said, 'It will go on and on. Save your children.' "

Galina went to Ludmila's funeral, in St. Vladimir's Cathedral. Ludmila in her coffin "had a blue face, and black marks on her throat." Galina was startled to see Esaulenko there. "I said to him, 'What are you doing here, murderer?' " After pausing as she tells the story, she adds distractedly, "He left her but took her purse. He went down the ladder with her purse."

The official cause of Rukhin's death was carbon-monoxide poisoning. A doctor let Galina know that he had found injection marks on her husband's thigh. A medical student said to her, "Don't you know that he was killed by injection before the fire?"

"Ludmila probably rebelled and was choked when she refused to cooperate with the murderers," Galina says. "They burned out the studio to cover the murder."

Galina has a large photograph of Rukhin's funeral, in St. Nicholas Cathedral—the tall body in the coffin, the religious vestments, the wild black hair, his child Lev beside his head, his child Lisa in her mother's arms, a priest officiating, people holding long tapers, artists and their wives holding tapers, a timeless Russian Orthodox scene.

Galina's eyes fill with tears. "After his death, I couldn't stop painting his portraits." Week upon week, she kept drawing or painting his face. Several months

after he died, she went to a reception at the Brazilian embassy in Moscow. Inside the door, the first thing anyone saw was a large painting by Rukhin—an unusual one in that its theme was representational even if it seemed to be semi-surreal. It was a close-in depiction of the scalloped shingles of the wooden dome of the wooden church on Kizhi Island, in Lake Onega. A K.G.B. woman, in an aproned uniform, was taking people's coats. Smiling warmly, she took Galina's monk-like robe. "After the reception, she wrapped my robe around my shoulders and closed her arms around me and kept it for a while," Galina says. "It was the best present."

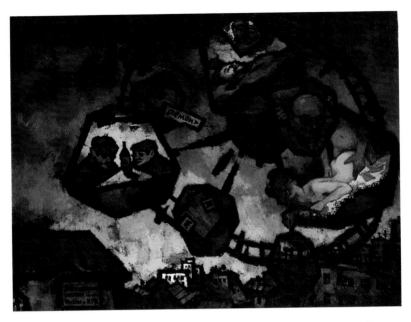

Oskar Rabin, *Ferris Wheel in Evening*, 1977. Oil on canvas. 31¾ × 43½ in. In the highest gondola is Rukhin in his coffin, in the next gondola clockwise is a self-portrait by Rabin, in the lower left is K.G.B. headquarters.

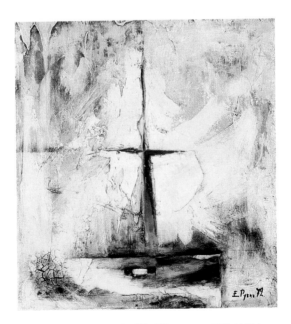

Evgeny Rukhin, untitled, 1972. Oil on canvas. 27½ × 26 in.

Vladimir Ovchinnikov, *Ward No. 6*, 1985. Oil on canvas. 55⅛ × 39 in.

Intrepidity now overcome by fear, Dodge made just one more trip. Not only did he sense that he had flouted the Soviets perhaps more than too much, but also he was entering a period of considerable exhibition in the United States of the work of the dissident artists, exactly what the Soviet government had been trying to prevent when it made the sale and export of underground art illegal. There were a dozen or more shows in New York, Washington, D.C., and other cities, and at various colleges and universities. Margarita Tupitsyn says of him, "His importance grew when people realized that he was seriously collecting art. He became famous when he did exhibitions." Fame was something that Dodge would have defined as having street recognition with the K.G.B. Rita Tupitsyn says that neither time nor political dissolution has served to allay this continuing fear. "He exaggerates his importance to the K.G.B.

He still believes that the K.G.B. is in power, and has files."

To the art already stored at Cremona, he added vastly more through the proficiency of his developed network: "People who would find works that they thought I would be interested in or find works that I specifically asked them to acquire. I don't know how these other people, necessarily, got the work out. Once I got known, I had stuff flowing in out of the blue." Galina Main—a name unknown to him—called him from Darmstadt. She was Russian. She was married to an American whose technological business was centered in Germany. She was in touch with certain unofficial artists in the Soviet Union and wanted to help them. To the Dodge collection, she became a prominent supplier of Bulatov, Faibisovich, and Gorokhovsky. More widely, she became "a major helper" in getting things out of Russia.

Eduard Nakhamkin was effective for Dodge in Moscow, Leningrad, and the Baltic states. Nakhamkin was mysteriously abducted for a time but, Dodge says, "he got loose." Kornetchuk covered much the same area as Nakhamkin and was equally effective, using her authorized monopoly on official art as a way of bringing out other things, too: "For me she was focusing on trying to get borderline or unofficial art." Two hundred works in the Dodge collection came from Azerbaijan through Alexander Glezer. Dodge used Swiss and German buyers as well, but, according to Kornetchuk, he

also "made connections with Russian dealers who were helping the Swiss and Germans, because he wanted to beat out the Swiss and Germans."

Basmadjian the Armenian—"able to get things shipped out that most other people couldn't get out"—was seen emerging from the hotel in Moscow, the day he vanished, with a young man on his right and a young man on his left. They got into a car. That was in 1989. Was one of those young men from the mafia and the other from the K.G.B.? Dodge shrugs. He says, "There is no way to know what Basmadjian had to do to get the work out—how many people he had to bribe, seduce, or whatever." Short and trim, with a shock of dark hair, Basmadjian grew up in Jerusalem and seemed to erupt fluently into the language of any place to which his travels took him. For Dodge, he, too, was an effective supplier of the work of underground artists in Moscow, Leningrad, Georgia, and the Baltic states, as well as Armenia. He had particularly close rapport with Kabakov, Pivovarov, and Yankilevsky. "To get their work out, he knew which buttons to press, which levers to pull."

Basmadjian sometimes arranged for things to be shipped from Moscow to Nancy Ruyle Dodge, omitting the Dodge part from her name to conceal and protect Norton, and using her address in the District of Columbia. Nancy strongly suggested to Norton that he not let this practice continue, because it might prejudice her obtaining a future visa. The practice continued. One

day, an Aeroflot plane landed at Dulles with paintings in it addressed to her. In disgust over the suppression of Afghanistan, freight handlers at Dulles refused to unload the Russian plane. The Soviet embassy had to unload the Russian plane. When they called her, she was not pleased to hear from them. "I was madder than a wet hen. I knew they had a fat dossier on Norton, but I didn't want to be known to them." In her Chevrolet Malibu sedan, she went to the Soviet embassy. Inside the door, she stared into the "bronzy pink wall-sized mirror" and wondered how many eyes were looking through it from the other side.

She was queried by "a stone face." Why did she want official paintings from the Soviet Union?

"For a show."

Forty-five minutes passed. Then she was told to pull the car into an alley and pick up the crate. The crate was too big for the Malibu. She called Norton, who was in Washington, and chewed him up a wall, and told him to come to the Soviet embassy. Before long, he appeared on Sixteenth Street in his old white pickup with the boxed-in back. Lining things up carefully in his rearview mirror, he nosed the truck into the embassy alley. This happened to be the day of a meeting of the board of the local chapter of the American Association for the Advancement of Slavic Studies. The meeting was to be held at 1776 Pennsylvania Avenue in the office of the journal *Problems of Communism*. Only Norton can finish the story: "So I load this

stuff up in the truck, assuming I am being photographed by the C.I.A. or F.B.I. I then get in my truck and I drive down and park near 1776 Pennsylvania Avenue. I go in, go up to the meeting, and sit down; and in come some of our board members, who are C.I.A. people."

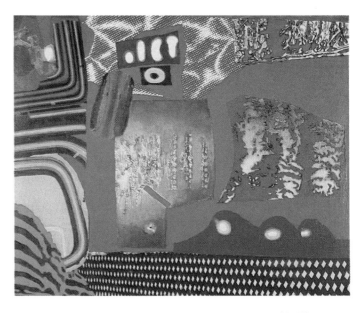

Yuri Dyshlenko, *Concise Guidebook* (No. 8 from a series of ten), 1976. Oil on canvas. 22 × 28 in.

Vitaly Komar and Alexander Melamid, *Young Marx*, 1976. Oil on dishrag. 32 × 24 in.

Erik Bulatov, *Krassikov Street*, 1976–77. Oil on canvas. 59¼ × 78⅞ in.

Sergei Sherstiuk, *The Cosmonaut's Dream*, 1986. Acrylic on canvas. 59⅞ × 79⅛ in.

Alexander Shnurov, untitled, 1985. Acrylic on canvas. 36¼ × 60 in.

Lev Nussberg, *Installations in the Science Institute*, 1971–72. Silkscreen. 12⅞ × 22 in.

Ilya Kabakov, unofficial superstar, whom Dodge met by walking on planks over the rafters of an apartment-building attic in Moscow, now lives and works in New York City. Ernst Neizvestny, unofficial artist, official sculptor of Nikita Khrushchev's tomb, lives and works in New York City. So do Ilya Murin, Dmitry Plavinsky, Valery Gerlovin and Rima Gerlovina, Leonid Lamm, and Leonid Sokov. Vasily Sitnikov, of the peasant boots and peasant blouse at Nina Stevens's Moscow salon—the artist with the kayak on his ceiling and the annunciatory string dangling from his apartment window—spent his final years in New York. Yuri Dyshlenko lives and works in Brooklyn, Mikhail Shemyakin and Igor Tiulpanov in Westchester County, Lev Nussberg in Connecticut, Vitaly Rakhman in Philadelphia, Alexander Anufriev and Sophie Schiller in Boston, Alexander Rapoport in San Francisco. Of the six hundred

[*169*]

artists whose work is in Dodge's collection, about a hundred live in the United States. When I visited Alexander Melamid, we talked in the small garden behind his house in Jersey City.

In the United States, the former underground unofficial painters live, for the most part, in very tight and overcrammed if not multifamily apartments where art reaches up to and sometimes over the ceilings. The Leningrad poet Konstantin Kuzminsky, friend and counsellor of dissident artists, lives at 78 Corbin Place, Brighton Beach, in Russian Brooklyn, a few doors down from Babi Yar Triangle. He inhabits space no less confined than the space he was accustomed to in Leningrad. His wife, Emma, answers the bell. You enter a short narrow hallway (made narrower by quantities of hung and standing art) and go past a bathroom with what appears to be a large dead borzoi in the tub and then through a small sitting room—its walls dense with art—and out onto a very small deck, where, in hot weather, lies Kuzminsky under trees of heaven, on his back, on a cushioned chaise, his body wrapped from knees to sternum in a black-and-white prison-stripe sarong. Half of the belly is exposed. Half of the belly is nonetheless a dune. His muscular legs suggest an athleticism that he may have left in Leningrad. There are actually three borzois living here—long-bodied, long-haired. The one in the tub is able to breathe without betraying the fact that he is alive. Emma is short and trim. Her hair is short and trim, a little white. She

serves Kuzminsky tea. She brings him cigarettes. She and he smoke cigarettes five inches long. Kuzminsky has tumbling brown hair and a split, thick beard. Around his neck in whalebone, or something like whalebone, is a kind of double cross, a patriarchal archiepiscopal cross. There is the faintest glimmer of Eastern Orthodox in his clear and amiable eyes, like light from the edge of the universe. His head is on a pillow and remains there as he lifts a hand in greeting. He appears to be as healthy and comfortable as a pharaoh on a pallet. Norton Dodge being among his favorite subjects, he talks of him for three hours. Dodge, like the chaise, has cushioned Kuzminsky. Toward the end of the interview, Kuzminsky says, "Norton is measuring Russian art through Western standards. For example, he overestimates Sotsart, a fashion understandable to the West: Kabakov, Komar and Melamid, Vassilyev, Lamm, and so forth. Norton thinks art is international. I insist it's purely national." To demonstrate that art is purely national Kuzminsky describes Vladimir Nekrasov's "crouching woman with six tits, with a shovel in her hands, making a railroad, and a cunt up in a place where you could use it without her sitting up." The clear eyes stare into the Brooklyn sky through leaves of the trees of heaven. He continues: "This is woman turned into animal condition in the Soviet Union. A Westerner would never understand. Nekrasov was Siberian. He lived in Novosibirsk. His work is too tough and too harsh for the American throat. Nekrasov is of

a kind of people who spread shoe cream on bread and
leave it in the sun, and after the alcohol goes into the
bread they scrape the cream away and eat the bread.
Norton appreciates them but he prefers Ovchinnikov.
Americans are afraid of everything which causes too
much emotion and tragedy. That is the problem be-
tween East and West."

Ovchinnikov, Rukhin's colleague and lifelong Len-
ingrad friend—who was with Rukhin in Moscow at the
dinner at Burelli Rivas's mansion the night before
Rukhin died—has become a favorite of mine for his
surreally rotund Russian figures presented in bright
colors and sketched in fine clear lines. I ask Kuzminsky
to develop his remark on Ovchinnikov. "A bad artist,"
Kuzminsky says right back. "Cheating. He is not artist.
I know him to the very guts. Together, we worked blue
collar in the Hermitage. He was the godfather of my
daughter, he is not honest. He doesn't know colors. He
took elements of Malevich (cylindrical forms), added
religious forms and folk scenes; and this Russian cocktail
is swallowed by every American."

As I am preparing to leave, Kuzminsky lifts his
head for the first time, rolls forward to a standing
position, and accompanies me to the door. It is only a
dozen steps but we seem to pass a hundred paintings,
the walls behind them rarely visible. He pauses be-
fore Vasily Sitnikov's *The Schoolteacher*. A red-haired
woman, naked, faces the viewer. She is bending for-
ward, and, in Kuzminsky's description, "holding tits

like rockets." Next to her is a Sitnikov self-portrait with kremlins under snow, and a whole series of his of earth and sky—alluring miniatures, low and wide—and another Sitnikov of a man lying flat on his back outside a rustic cottage with his hand between the legs of a pig. Kuzminsky says, "A man touching a pig by her pussy. There is a sense of humor in him always. He died in the East Village in '86. His work went into a dumpster."

There is a Neizvestny of a squatting male figure, nude, his spine curved to the sticking point in an autostimulant act. The subject of the painting is at the same time reading a newspaper. Kuzminsky says, with a wave of farewell, "There is a Russian proverb: Suck yourself and read your newspaper, and you'll be a Chief Prosecutor by summer."

Sarah Burke still lives in San Antonio, where she was living in the nineteen-seventies when she went to Leningrad and met Evgeny Rukhin. She still teaches Slavic language and literature at Trinity University, and still goes to Russia: "In the old days you might be hassled by the K.G.B. but that was all, whereas now you'd get mugged." She lives in a dramatic brick-and-glass modern house under tall live oaks, 4.1 beeline miles from the quiet neighborhood and roomy loft where Galina Popova lives now. She and Sarah are not inimical when they happen to meet. Each tells the story of Lenin Park and the heaving of the handbag in the Leningrad zoo. There is one point at which the stories don't match.

Burke says that Popova threw the handbag to tigers; Popova says she threw it to lions.

About three years after Rukhin's death, Popova emigrated to New York, where she learned to make jewelry, a skill that led her to a jewelry-making enterprise in San Antonio. She has made herself gold earrings, each in two parts, each with a signature Rukhin hinge. The lower parts swing. She is rather short, which makes all the more prominent the hexagonal lenses of her eyeglasses, which generally ride on top of her head. Her hair, now graying, is cut in short bangs. Hanging on a chain around her neck is an eighteen-carat-gold icon of her own making. The Rukhins on her walls incorporate many icons and bits of furniture. Rukhin once wrote: "I use pieces of furniture—old broken chairs, tables, boxes, and other objects which civilization has discarded as useless. They lose their concrete or even schematic reality and are reborn into abstract shapes and patterns." With the help of friends, Popova brought out of the Soviet Union about two hundred Rukhins, some of which had been in the studio but were still marketable after the fire. Sarah Burke turned over to her another hundred and fifty. Many of these are still in a warehouse in San Antonio. Rukhin's and Popova's son Lev—a big amiable American kid who bungee-jumps—sold one of his father's paintings to buy a Jeep. Popova has sold a number of canvases to pay for the storage of the rest.

Only a few of the unofficial artists have flourished

[*174*]

economically in the West. "Their suppression stimulated them," Popova says. "Look at them now. No one is interested. When their work was underground, people were interested. Yuri Petrochenkov went to Paris. He wrote back to Russia. He said, 'Don't follow. Nobody is interested.' They didn't believe him. They thought he was an agent." A Rukhin in the present market will bring anywhere from eight thousand to twenty-five thousand dollars, high for a former dissident artist. A Bulatov will bring comparable sums. Sitnikov (of the pig's pussy—"there is a sense of humor in him always") has sold for as high as forty thousand. These are not numbers that would cause a Frank Stella to glue hinges to black squares. They are disappointing numbers to the once-underground artists whose beguiled sense of Western possibility was driven suddenly upward in 1988, only to fall like a pyrotechnical novelty. The renowned Sotheby's auction in Moscow was in 1988 (about three years after the end of the era represented in the Dodge collection). Elena Kornetchuk tells of it in an anecdote about the price of a Glazunov. Before the Sotheby's auction, she says, Ilya Glazunov was "fairly well known internationally," probably more so than any other unofficial artist. Before the event occurred, Kornetchuk had a Glazunov in her Pennsylvania gallery that she was offering for three thousand dollars. In the auction, a Glazunov sold for sixty thousand. A week later, Kornetchuk was offered fifty thousand for hers. "With Sotheby's, the unofficial artists entered the international art market,"

she continues. "Suddenly, everybody in Russia thought they could get at least fifty-five thousand." And why not? Such a thought suddenly seemed modest. Grisha Bruskin, of Moscow, who was not in the front rank of unofficial artists, sold a piece at the Sotheby's auction for more than four hundred thousand dollars. It was a large checkerboard affair, eight squares by sixteen—each square a work of art distinct from all others. It was, in effect, a hundred and twenty-eight paintings for the price of one.

Sotheby's Moscow auction was a stimulus to emigration, although a great many artists were not there to be stimulated, having long since gone. Deracination did not improve their lot. A fair number of them had been much impressed when they learned that their work had been exhibited in America. "They imagined that every American saw their shows," Victor Tupitsyn remarks. "This was their mythology."

Margarita Tupitsyn adds, "This is why they became so disillusioned when they came here."

Jonathan Ingersoll, the art-museum director at St. Mary's College of Maryland, who has the appearance of a Marine who became a camp counsellor, summarizes the situation in a few hard words: "They have to make it here like everybody else. It doesn't matter how tough a time they had."

It matters to Norton Dodge. While he has been more inclined to foster artists in their environment than in alien settings, he has been forthcoming to a fault

with respect to the needs of the painters wherever they might be. He has helped to support Rabin in Paris, Bulatov in New York, Popova in Texas—not to mention Kuzminsky in Brooklyn. Bulatov's going rate of forty thousand a painting seems to be a level set and maintained by Dodge. "He has spent everything—his money, his time, his spirit, his soul," Popova has said. Soon after she arrived in New York, he paid her fifteen hundred dollars for one of her posthumous portraits of Rukhin, enabling her to take an apartment.

Rita and Victor Tupitsyn live on Chambers Street in Manhattan in a long airy spotless loft where paintings of their colleagues—Kabakov, Bulatov, Monastyrsky, Masterkova—are displayed in spacious separation. Masterkova, who now lives in Paris, is Rita Tupitsyn's aunt. Dark-eyed, dark-haired, slight, Rita looks half her age. She looks nineteen. She was about that age when she and Victor participated in the bulldozer exhibit in Moscow. Victor, hair cut short, is tall, slim, contemplative. For City University, Rita has just completed her doctoral dissertation in art history. She calls the Dodge collection "an unsorted archive," and says, "It will take a lot of time for people to sort it out. Before perestroika, no one was interested. By breaking up, they made his collection important and gave it a lot of power. Because galleries began to exhibit them, the artists became important. If the present is unimportant, its past is, too. Who wants to know the past of an unknown present?"

Of the nine thousand works in Dodge's collection,

only about seven hundred have been exhibited, and those in scattered groups and briefly. Like rock strata and the record they bear, the rest have remained in the darkness of storage. Recently, though, trucks began arriving at Cremona Farm to transport the paintings to New Jersey. The Metropolitan Museum and the Museum of Modern Art once tried to buy certain outstanding pieces from Dodge and take them to New York, but he wanted to keep the collection together. Columbia University said to him, in effect, "Give us a building; we'll take your collection." He talked with the University of Wisconsin. Nothing came of it. The University of Maryland could not offer adequate space. In New Brunswick, New Jersey, Rutgers University already had its Riabov Collection of Russian Art—more than a thousand works, from five centuries, and a supporting library of eight thousand books. Its Zimmerli Art Museum guaranteed in perpetuity ten thousand square feet of continuous exhibition space to the Dodge collection. That could accommodate at least eight hundred paintings at one time, and the offer promised that the entire body of work would be presented in rotation. Holding back only a modest number of paintings for his own enjoyment, Dodge gave his collection to Rutgers. He held back, among other things, a Kharitonov, a Leis, a Mikhnov-Voitenko, a Nemukhin, a Krasnopevtsev, an Ovchinnikov, a Shteinberg, a Belenok, an Infante, a Kabakov, a Kalinin, a Pivovarov, a Plavinsky, a Tiulpanov, and three Rukhins. He explains about one

of those, "I paid through the nose for it recently."

It has been said that after perestroika and glasnost, when it became possible in the Soviet Union for unofficial artists to exhibit their paintings openly, there weren't any paintings to show—they were in the United States. That is not a large exaggeration, and since by far the greatest number of those paintings are in—as it has been fully titled—the Norton and Nancy Dodge Collection of Nonconformist Art from the Soviet Union, anyone in Russia or around the world who wants to see or study them will need proper documents, official papers, and an Intrenton visa to visit New Jersey.

"Even if only ten percent of it is good, that is enormous," Rita Tupitsyn says, making a large point.

"Not a collection but a picture of the Russian past is how Norton sees it," Victor inserts. "Norton is an egalitarian educator."

"The idea of education and representation—so that American people can understand Russian people—is what is important to Norton and not aesthetics," Rita continues. "Norton is still collecting, still filling gaps, and he is still not interested in art. His collecting is an obsession. His tolerance is incredible."

One morning in the heat of July, I met Dodge at the Amtrak station in Trenton and drove him into New York, where he had arranged to call on Alexander Shnurov, who left the Soviet Union in 1988. As we came off the turnpike and crossed the George Washington Bridge, Dodge described Shnurov to me as a

young nonconformist artist who started out doing street exhibits in Moscow in the early eighties, his themes eventually including cosmological mysteries, plastic-foam *objets trouvés*, and defaced portraits of members of the Politburo. "He does a personalized version of Sotsart, much of it on a very large scale, with political messages in it—bureaucrats and officials presented as monsters. He was given a psychiatric examination and declared a mental case, and therefore was not drafted and sent to Afghanistan. He also does T-shirts. It might be nice if you were to buy one."

Shnurov's apartment, on 186th Street, could have been in Moscow. It was small, tight, and jammed with paintings that all but covered every wall. Shnurov lived there with his wife, his daughter, and a rabbit larger than a spaniel. The windows were open. Near them, a powerful standing fan was blowing air down the room at high speed, not much offsetting the heat. On the walls, Shnurov's very large canvases of smoke-blue figures included a front view of a sitting woman, her legs apart, her vagina dilated far beyond the requirements of known obstetrics. Inside her, peering out, was an oppressed-looking adult head with furtive eyes. Shnurov himself looked furtive, thin, as if he had not had much to eat and had never thought about it. He sold me a T-shirt on which he had painted a thick-bodied snake with the head of Lenin. Over the floor, he spread official black-and-white posters of high Soviet officials that he had artfully altered—adding blue or

magenta mustaches and such—in a manner that would once have been daring. He hoped that Dodge might buy the posters. On a New York floor in the nineteen-nineties, they did not seem highly negotiable. Dodge studied them with interest and committed himself to nothing. After a time, he presented Shnurov with a packet of money, saying that it was not for anything specific but was "a general down payment." Shnurov took the money shyly, and began to put it away. Dodge urged him to count it. He opened the packet and began to shuffle hundred-dollar bills, fifty-dollar bills—in all, at least a thousand dollars—and as he was leafing through bills the fan blew them out of his hands and suddenly fifty-dollar bills and hundred-dollar bills were flying around the room like leaflets in wind. The money fell all over the Politburo, and Dodge said, "It's a good thing the air is coming in."